David Be

Seas & Shorelines
IN WATERCOLOUR

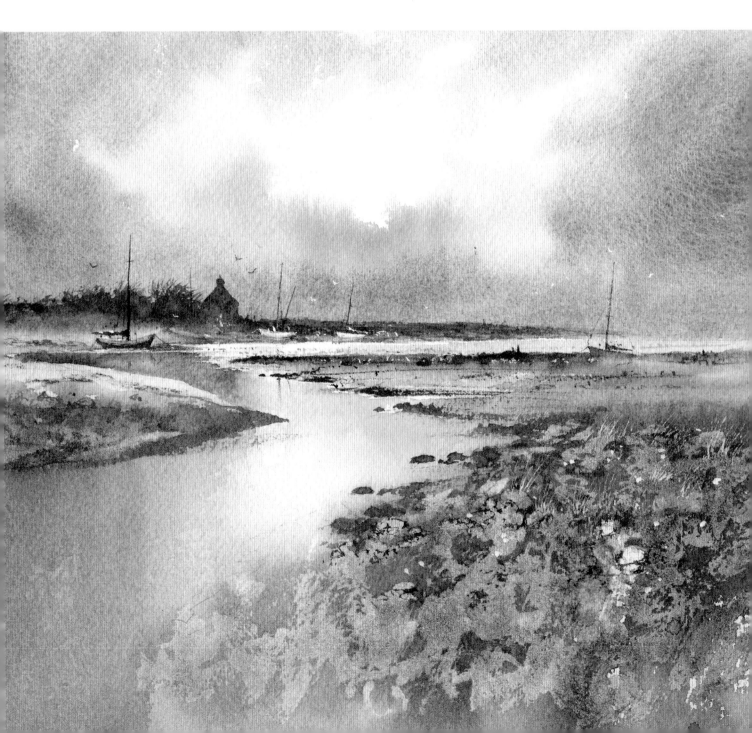

Dedication

*This book is dedicated to the many extremely tolerant
skippers, from the Arctic Sea to the Indian Ocean, who have
manoeuvred their craft in less than perfect seas into some
tricky and decidedly dodgy positions, so that the author could
capture that stunning view of some heaps of rocks.*

David Bellamy's
Seas & Shorelines
IN WATERCOLOUR

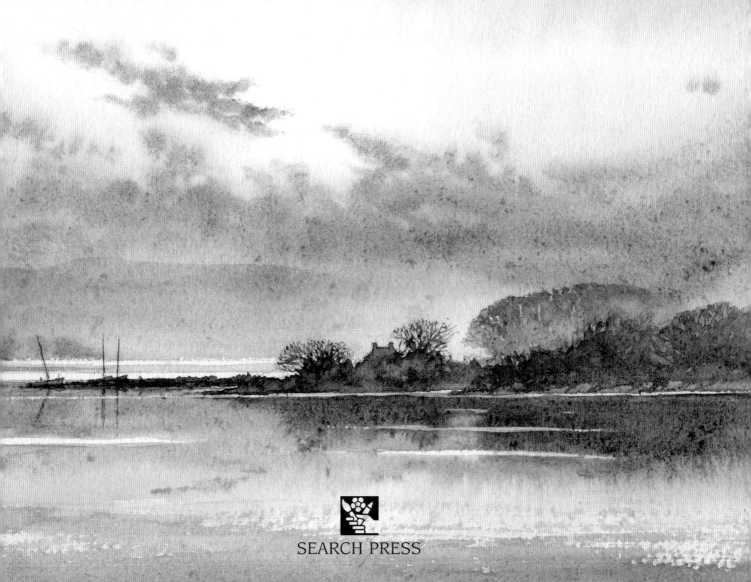

David Bellamy

SEARCH PRESS

First published in Great Britain 2019

Search Press Limited
Wellwood, North Farm Road,
Tunbridge Wells, Kent TN2 3DR

Illustrations and text copyright © David Bellamy 2019

Photographs by Paul Bricknell at Search Press Studios

Photographs and design copyright © Search Press Ltd. 2019

ISBN: 978-1-78221-672-8

The Publishers and author can accept no responsibility for any consequences arising from the information, advice or instructions given in this publication.

Suppliers
If you have difficulty in obtaining any of the materials and equipment mentioned in this book, then please visit the Search Press website for details of suppliers:
www.searchpress.com

Publishers' note
All the step-by-step photographs in this book feature the author, David Bellamy, demonstrating his watercolour painting techniques. No models have been used.

You are invited to visit the author's website:
www.davidbellamy.co.uk
His blog, with free painting tips, can be accessed via the website.

Acknowledgements

I am indebted to Edward Ralph for editing these pages, Juan Hayward for his creative design talents and Katie French at Search Press; and to Jenny Keal for checking the manuscript.

Front cover
Heavy Seas, Grassholm
38 x 25.5cm (15 x 10in)
This painting can also be seen on page 70.

Page 1
Ebbing Tide
33 x 25.5cm (13 x 10in)

Pages 2–3
Teign Estuary
40.5 x 25.5cm (16 x 10in)

Opposite
Pounding Waves, St. Brides
45.5 x 30.5cm (18 x 12in)

Contents

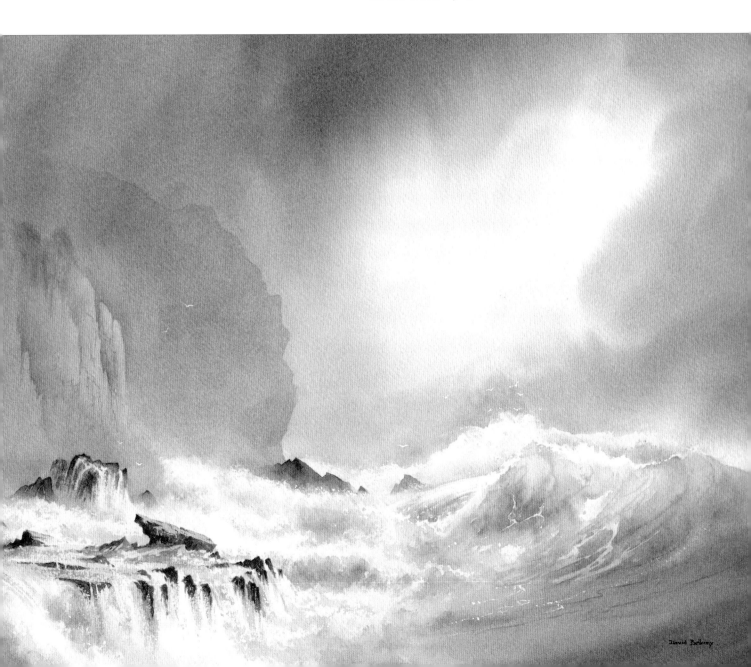

Introduction

Painting by the sea has always been a popular activity for both the occasional painter and the professional. Sitting on the beach sketching, working up a simple drawing at a quayside café, or painting on the deck of a cruise ship makes up a pleasurable part of a summer holiday for some, while to others it is a year-round activity in all seasons. The combination of painting and enjoying the sea environment is especially therapeutic, taking you away from the debilitating haste and stresses of modern life. While you are encouraged to work from this book indoors, never has it been so easy to collect images of your own to work from, so I do urge you to go forth with a sketchbook and pencil, alongside a camera, smartphone or similar gizmo, and capture those fascinating scenes on the coast.

Before you go outside, however, the book guides you in how to tackle the various types of subject found on the coast, so that you gain both experience and confidence in drawing and painting before having to undertake these terrifying pleasures. Don't feel you need to create crashing waves, intricate boat designs, complicated harbour scenes or confusing cliff structures, as there are simple alternatives to each of these, as will become apparent. You are encouraged to begin with the easy approach and then gradually build up your expertise until you are working on more complicated scenes once you feel able to tackle these.

Whether you paint in a realistic fashion, or prefer the kind where it is not really necessary to attach that mast to the boat, you will find a wealth of techniques and ideas in the following pages. My own work in watercolour tends towards the more traditional methods of working, but with the development of so many additives and exciting new approaches to using the medium, I have brought in some additional techniques such

Breaking Wave
25.5 x 18cm (10 x 7in)

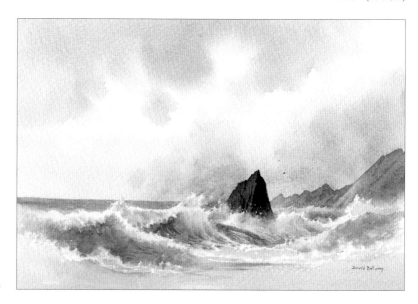

as collage, monoprinting, textural effects and additives that will push the boundaries of your watercolour painting. Throughout the book you will come across a wide selection of skies and moods which you can transfer to your own compositions. In later sections you will find out how you can improve your compositions, get the best out of your photographs, and introduce figures and seabirds into your work.

Don't despair if things go wrong – with perseverance you will find your work progressing even without you realizing. You paint because it gives you pleasure, and the aim of the book is to encourage you to enjoy the experience of capturing the fascinating world of sea and shoreline.

Haroldston Chins
45.5 x 30.5cm (18 x 12in)

The cliffs are at their most interesting where they are crumbling away, and thus providing a focal point in this watercolour.

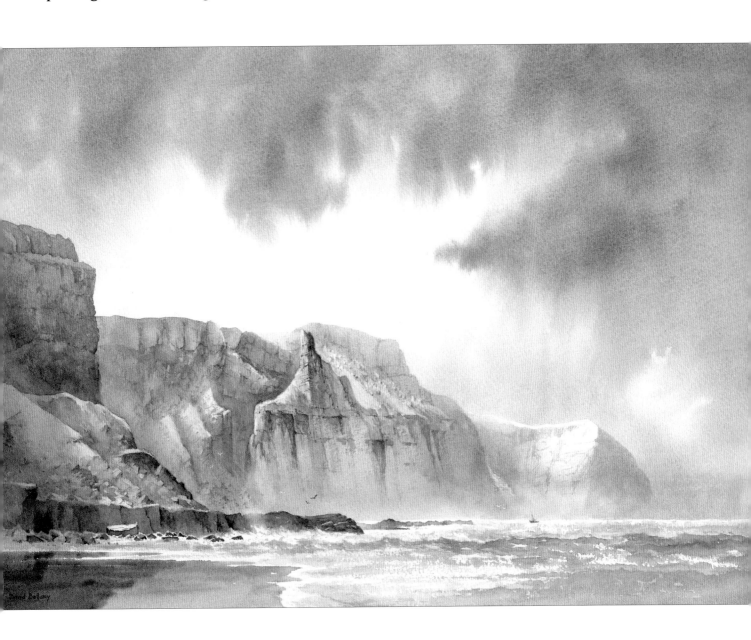

Materials

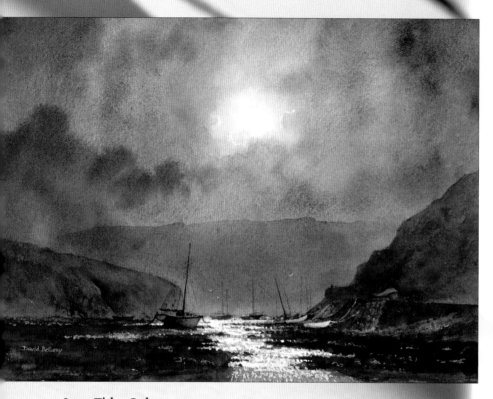

Low Tide, Solva
28 x 20.5cm (11 x 8in) 425gsm (200lb) tinted Not paper

A watercolour carried out on tinted paper. This is an excellent way to create unity and atmosphere in a painting.

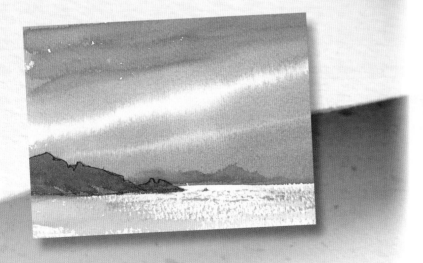

Evening Light, Naxos
15 x 10cm (6 x 4in) 640gsm (300lb) Rough paper

This watercolour sketch done on Rough paper shows how you can achieve sparkling light on the water with a brush loaded with pigment but very little water, and dragged across the surface.

Watercolour paper

Watercolour paper is best bought in imperial-sized sheets, which can be cut to whatever size and configuration you wish, although various pads and blocks that are glued all round the four edges to avoid having to stretch the paper are excellent, especially when working away from home. Usually it comes in weights of 190gsm, 300gsm, 425gsm or 640gsm (respectively 90lb, 140lb, 200lb or 300lb), with some manufacturers having a more extended range. 640gsm (300lb) paper is as thick as cardboard, while 300gsm (140lb) paper usually needs stretching before painting, so many people find the 425gsm (200lb) paper offers the best of both worlds: it does not need stretching unless you are painting larger works, and it is less expensive than the 640gsm (300lb) weight.

Most papers come in three types of surface: Rough, Hot pressed and Not (or Cold Pressed). Hot-pressed paper is smooth and brilliant for fine detail, but you may find it best to leave this surface until you are more experienced as it dries rather more quickly. A Rough surface is extremely effective for creating textures, ragged edges, or with the dry-brush technique to lay a broken wash, although it is not best for fine detail. The most popular paper is the Not surface which falls between the other two types in degree of smoothness.

Buy a few sheets from different manufacturers to test which suits you best. Most of the paintings in this book are done on Saunders Waterford which has an interesting surface texture and responds well to washes.

Paints

Watercolour paints are available in tubes, pans and half-pans. I normally use half-pans for out of doors sketching as they are more convenient. For the larger studio paintings tube colours tend to be better as one can quickly mix large washes. Choice of colours is up to the individual, my own being fairly traditional. I always work with artists' quality paints as they are more powerful and finely ground, but the students' variety are cheaper and perfectly adequate while you learn how to paint in the medium.

If you are new to painting, start with just a few colours and get to know them well before adding further ones. My basic colours are: French ultramarine, burnt umber, cadmium yellow light, cadmium red, cobalt blue, phthalo blue, permanent alizarin crimson (or quinacridone red), new gamboge, light red, yellow ochre, plus white gouache for minor highlights.

Add the following colours when you feel confident, but preferably not all at once: burnt sienna, raw umber, aureolin, viridian, indigo, cerulean blue, Naples yellow, cadmium orange, raw sienna, vermilion.

More recently I have been using the Daniel Smith Extra Fine range of watercolours because I love their wide range of granulating colours, as well as some of the new spectacular pigments. Colours in this range that I particularly like and recommend for coastal landscape painting are: transparent red oxide, sodalite genuine, Aussie red gold, moonglow, green apatite genuine, bloodstone genuine and lunar blue.

All the paints shown above have excellent permanence. Study the manufacturers' labels and leaflets to avoid any fugitive colours. These will also tell you if the colour is transparent, opaque or falls between the two.

If you are not using Daniel Smith colours, you can approximate the colours as follows:

- **Nickel titanate yellow** Naples yellow.

- **Sodalite genuine** a mixture of burnt umber and French ultramarine (note that sodalite genuine induces much stronger granulation).

- **Green apatite genuine** French ultramarine mixed with cadmium yellow pale for light greens; and raw sienna or yellow ochre for duller greens.

- **Transparent red oxide** light red.

- **Moonglow** a mixture of French ultramarine and cadmium red.

- **Aussie red gold** cadmium orange, but it is more opaque and not quite so vibrant.

- **Bloodstone genuine** a warm black is the closest equivalent, though you are unlikely to find a combination that granulates like Bloodstone genuine

- **Lunar blue** This is really quite unique, with strong granulations that can vary unpredictably, and often in a delightful way. There is no simple replacement.

Brushes

Although the finest brushes for watercolour are undoubtedly sable, there are many excellent ranges of synthetic brushes on the market. Kolinsky sable brushes have a fine tip, a large belly to hold copious amounts of paint, and the ability to spring back into shape and not lie limp after one brush stroke. A good compromise, if you find sables too expensive, is to buy a brush of mixed sable and synthetic hairs. Large squirrel-hair mops make lovely wash brushes, although they are prone to losing the odd hair now and then.

The minimum brushes would be a large squirrel mop for washes, a no. 7 or 8 round, a no. 4 round, a no. 1 rigger and a 12mm (½in) flat brush. Add a no. 10 or no. 12 round and a no. 6 round when you feel the need and you are well set up.

More specialized brushes for certain applications, such as a fan brush, can also help on occasion, but they are not essential. Take care of your brushes and they will last well. Wash them out with clean water after use. Most of the brushes I use are made by Rosemary & Co.

Pencils and pens

I use a selection of pencils: generally a 2B for drawing buildings, and a 3B or 4B for initial pencil work on a watercolour painting as these softer pencils are easy to erase if the lines intrude after the work is finished. The 3B and 4B are also excellent for sketching, but sometimes I need something stronger and a 7B can produce some lovely dark effects.

I also work with a variety of pens, mainly black, sepia, grey or sanguine, sometimes combining them in one sketch. A putty eraser is vital to remove intrusive pencil marks and smudges, but don't over-use them!

Other materials

Other items you will need include a drawing board, a soft sponge, at least one large water pot, masking fluid and a scalpel. Also useful are bulldog clips, an old toothbrush for spattering, tissues and rags. I find a plant spray is useful to speed up the mixing of colours accurately and occasionally for spraying over a damp wash to create a speckled effect. If you intend stretching papers then a roll of gummed tape will be required.

You will need a large palette on which you can lay out the colours you are using, many of which will be for small areas of detail, and some for slightly larger areas. A palette with deep wells is needed for mixing up pools of colour for the main washes. Many artists prefer to use a saucer, butchers' tray or large plate, and so long as it is white and does not affect the way you see the colours, these are perfectly fine. For a large wash the whole saucer would be needed, but for small detail many mixes can be placed on a single dinner plate.

A hairdryer is useful for speeding up the drying process, but be aware that it can spoil any granulations present and also make it difficult to remove masking fluid.

The other materials I find useful for painting; both in my studio and outside.

Sketching outdoors

If you are tentative about sketching out of doors, then start with a minimal kit of a small cartridge pad, a couple of ordinary pencils, a water-soluble pencil and a water brush. The synthetic brush-tip of the water brush is attached to a hollow plastic handle which you unscrew to fill with tap-water, and this works well in combination with the water-soluble graphite pencils.

Try working with this small kit and, when you gain confidence, add a small box of watercolours in half-pans, a few brushes and a waterpot. Most watercolour boxes include an integral palette in the lid. Cartridge paper can be difficult to work on with watercolours until you are used to it, so you might prefer a small book of watercolour paper. Later you can expand this kit to suit your needs.

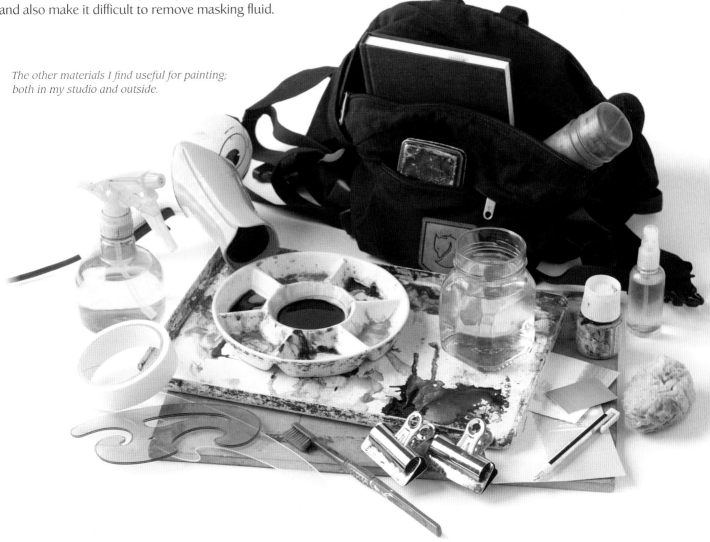

Working with watercolours

Handling fluid washes

Mixing and applying watercolours are two of the greatest problems facing the inexperienced artist, and there is no alternative to practising laying washes as often as you can. I would emphasize that testing your mixtures out on scrap paper first, before laying on the wash, is vital.

The amount of water you use in a mix is critical, and for larger washes you need to mix a pool of fluid watercolour that will more than cover the area you wish to paint: there is nothing worse than running out of colour halfway through the application and having to stop to mix more colour while the already-laid colour is rapidly drying. The most likely result then is ugly runbacks forming as a new wet wash is introduced to a drying one.

As you apply the paint, it is better to get it right first time than to apply multiple coats of washes, or you risk creating a muddy result. The mixture also needs to be strong enough in tone to give the result you desire, bearing in mind that watercolour tends to play the nasty trick of drying lighter than it appears when wet. Only experience will give you the expertise to overcome this.

The answer is to waste a lot of paper conducting test washes before you tackle the real thing on your composition. Make your mistakes on scrap paper, or on the back of failed watercolours. Use as large a brush as you feel confident with, for the fewer the strokes you apply, the cleaner your wash will appear.

Creating a watercolour wash

In order to lay down an area of colour you need to mix a fluid pool of paint to apply with a reasonably large brush. Use an old brush that you save only for mixing.

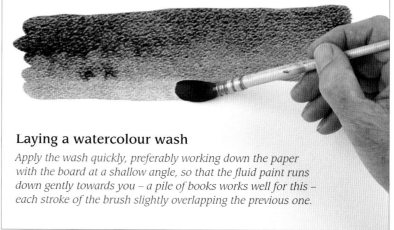

Laying a watercolour wash

Apply the wash quickly, preferably working down the paper with the board at a shallow angle, so that the fluid paint runs down gently towards you – a pile of books works well for this – each stroke of the brush slightly overlapping the previous one.

Altering the tone

If you want to lighten the wash as you progress, then simply add a little more water to the mixture. If you wish to darken it, then add more of the appropriate colour.

Wet-into-wet technique

This popular and exciting technique takes some experience to achieve good results, but is an excellent way of creating moody scenes and soft effects in a painting. First of all you need to lay out and mix all the colours you will need, as timing is critical – searching for tubes of paint while a wash is drying is a recipe for disaster. If that does happen, it is best to leave the first wash to dry completely (use a hairdryer to speed up the drying process if you wish, but be aware that this will spoil any granulations you may want to leave present).

Once the wash has dried, re-wet it with clean water then apply the second application, watching for the right moment. Getting the timing right to introduce the second application of paint can be tricky: too soon and it will spread out weakly and lose its shape; too late and it may well induce ugly cabbage-like runbacks into the wash. After applying the wash, look for reflected light showing up the sheen on the drying surface. When you see the sheen starting to dry, that is usually the optimum moment to introduce the second application of colour.

Testing it on the side of the painting, or a point where any error can be overlaid, is a sensible way of assessing the result. With the introduction of the second wash of colour, make sure that the consistency is strong enough and that you don't have much water on the brush, as this will also encourage runbacks. With time and experience in laying wet into wet washes, you will find your expertise will improve.

Misty cliffs wet into wet

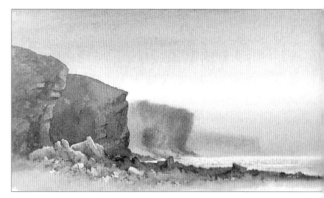

1 Firstly, paint the sky with a really fluid wash, bringing it right down to the horizon, then allow it to start drying before applying paint to the distant faint headland – too soon and the headland wash would spread out too weakly and too far; while if left till too late, the edge would become hard, thus bringing the headland too close to the viewer. There is also the danger of runbacks forming, especially if you introduce too much water in the second wash.

2 Add the darker tones of the closer cliffs and rocks once the paper has dried. Some light red was dropped into the foreground to complete the painting.

Quiet Creek
33 x 25cm (13 x 9¾in)

One extremely effective technique is to place a sharply defined feature against a soft or hazy background. Start with a wet into wet backdrop as in this creek scene, before creating strong detail on boats and shed. The dull greens lend atmosphere and also establish a quiet area in the composition that makes the centre of interest – the boats and shed – stand out so much more. By dropping in the dark greens while the background was still damp, the misty edges of the mass of trees have been achieved.

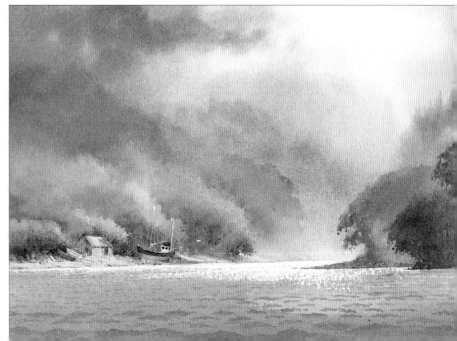

Making the most of colour

Colour mixing

With watercolour we need to mix various colours to create the exact one that we require. Mixing more than two colours can be fraught with a tendency to produce a muddy effect, but sometimes a third colour is required, in which case only a touch of colour is generally needed.

As with so many aspects of working in watercolours, testing the results of your mixtures on scrap paper is vital before diving into the fray. While I have suggested a few mixtures here for achieving colours for the sea, it is really aimed at giving you an idea of how to approach mixing colours generally. Try out a variety of colours for mixing for the passage you are working on. It's possible to obtain similar results with combinations of different colours.

Create charts of your favourite mixtures – it is frustrating to find a brilliant combination of colours and then forget which ones you used when next you wish to achieve that end colour.

Colour temperature

Choice of colours can depend on whether you desire a warm or cool effect. While it is easy to see that a red is warmer than a blue, blues – indeed, all other colours – can vary in temperature. The examples below show the warmer colour in each case on the right.

| Phthalo blue (cool blue) | French ultramarine (warm blue) | Alizarin crimson (cool red) | Cadmium red (warm red) | Cadmium yellow pale (cool yellow) | New gamboge (warm yellow) |

Effects of adjacent colours

When you place a colour next to one already laid down, the colours are affected by each other. For example, a cool colour such as phthalocyanine blue placed beside warm Aussie red gold will make that colour appear even warmer.

Other effects can also be achieved. Placing an intense indigo alongside Aussie red gold will create a strong contrast – extremely useful in highlighting a centre of interest, for example; while if warm sepia is adjacent to the Aussie red gold, it has the opposite effect, creating a sense of harmony as the two colours lie close together on the colour wheel.

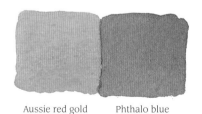 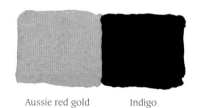

| Aussie red gold | Phthalo blue | Aussie red gold | Indigo | Aussie red gold | Warm sepia |

The cool blue makes the Aussie red gold appear to be even warmer.

The intensely dark indigo creates a striking contrast when set against Aussie red gold.

A sense of harmony is created by having another warm colour next to the Aussie red gold.

Useful sea mixtures

The colour mixtures shown to the right are effective for basic sea greys. They range from light to dark, warm to cool, and I often use two of the mixtures in the same sea scene, with a cool mixture in the distance and a warmer, stronger band closer to the foreground.

Additionally, while the wash is wet, I commonly drop in other colours such as cadmium yellow light, yellow ochre or phthalo blue. These grey mixtures are far from exhaustive and can be achieved with a variety of colours.

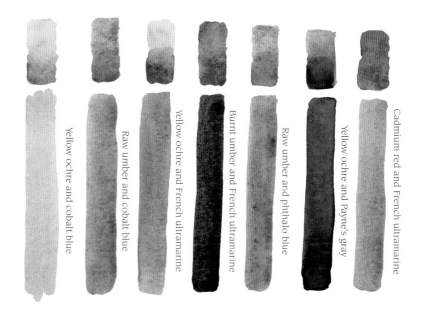

Yellow ochre and cobalt blue

Raw umber and cobalt blue

Yellow ochre and French ultramarine

Burnt umber and French ultramarine

Raw umber and phthalo blue

Yellow ochre and Payne's gray

Cadmium red and French ultramarine

Dropping in colours

In addition to mixing paints on the palette an effective way of introducing colour is to drop it into a wash already laid on the paper; in other words, mixing it on the paper. This technique needs to be done immediately after laying the main wash, otherwise runbacks may well rear up out of the drying colours. As with the wet into wet applications (of which this method is a variant), you need to restrict the amount of water on the brush as you drop in the additional colour.

This technique can really liven up an area and add considerable interest without the need to introduce strong detail. Whilst you can try any colours in this role, I find excellent ones to drop in are yellow ochre, cadmium orange, phthalo blue, cadmium red, Aussie red gold, transparent red oxide and quinacridone gold. Yellow ochre is especially effective as it is something of a bully, pushing other colours aside and thus often inducing spontaneous happy accidents.

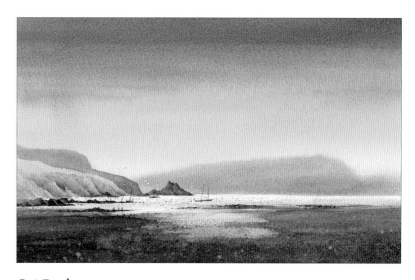

Cat Rock
30.5 x 23cm (12 x 9in)

By dropping a strong red into the wet colour on the rock this feature has been enlivened and strengthened as a focal point.

Stormy Seas, Linney Head
45.5 x 30.5cm (18 x 12in) 300gsm (140lb) Rough paper

In this painting I have dropped colours into wet passages in various places, including cadmium yellow pale into the sea and permanent orange into the cliffs in two places. Note the strong granulation (a feature of so many of the Daniel Smith colours) in the sky, where sodalite genuine has been mixed with moonglow. The latter colour has also been used on the cliffs to maintain unity. The choice of a relatively heavy, textured paper served to enhance the cliff textures and the ragged edges of the waves.

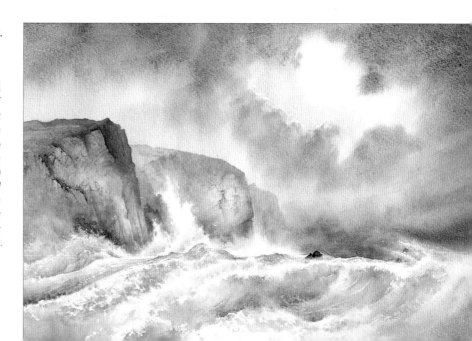

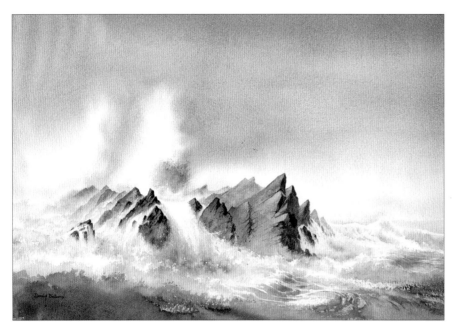

Detail from Atlantic Fury

Here I have exaggerated the tonal range on the right-hand rocks by making those slightly further away much lighter than they actually appeared, to emphasize that they are receding and thus giving more depth to the scene.

Tonal values

Tone is the degree of lightness or darkness in a colour and is controlled by how much water you include in the mixture. Adding more water will lighten the tone.

The range of tones you can achieve in different colours varies considerably: indigo, for example, being a dark colour, has a wide range of tones, whereas cadmium yellow light, being inherently such a light colour, allows much less scope for tonal variation.

Strong tones will make a feature appear to come forward towards the viewer, while weak ones recede. In a landscape we use this to suggest an illusion of space and distance, often exaggerating the degree of tonal variation to highlight a feature, or bring it more forward than it actually appears in real life.

When considering how we are going to paint a passage we need to consider what we have already laid on the paper – if there is to be a strong contrast in tones, then this is going to draw the eye towards that feature, which is an excellent method of highlighting your centre of interest. If, however, you wish to play down a feature, then painting with a fairly similar tone to the adjacent passage will achieve this.

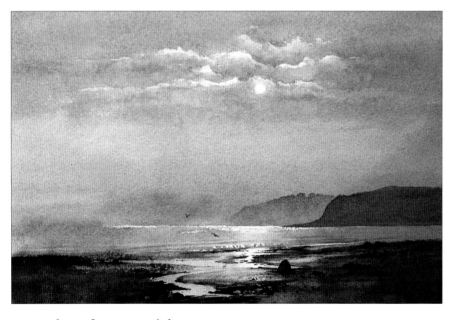

November Afternoon Light
30.5 x 21.5cm (12 x 8½in)

The backlit effect increases the mood, with hardly any colour. The composition relies on tonal variation to suggest distance. Note that the dark rock in the foreground stands close to the light rivulet, the contrast in tones accentuating the focal point.

Additional techniques

Watercolour is a fascinating medium for experimenting with methods of working besides applying paint with the brush. There is only limited room in this book for introducing extra techniques, but hopefully these will inspire you to try other ways of bringing in new ideas to your work.

A number of watercolour additives are available on the market and these seem to be on the increase. While some are effective, others have only limited value. If you like the effect of granulation in a wash, bottles of granulation medium are available which you can introduce into your mixtures, although you do need quite a considerable amount to produce really strong granulations.

It's great fun to experiment with materials to hand, such as credit cards, cut-up pieces of mount-board or watercolour paper, plastic food wrap, odd pieces of material mono-printed onto your composition with a roller, and whatever your imagination suggests. Having an occasional day experimenting in this way can be liberating!

Pulling out colour

This rock shows an interesting way to create an image; by pulling out the colour whilst still damp, using a credit card.

In this particular example I have enhanced the effect by mixing the colour with Winsor & Newton Aquapasto medium, which adds body to the mixture and makes lifting out easier.

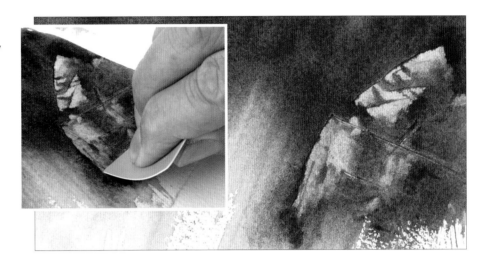

Monoprinting

The pattern of netting on a lobster pot can be achieved by painting the pot dark, and then either scratching the netting out with a scalpel, or painting it on with white gouache. Small areas can also be suggested by negative painting, but in this example I will use the monoprinting method with a small section of netting that comes with washing products.

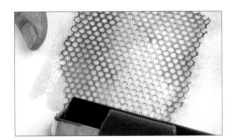

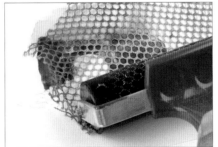

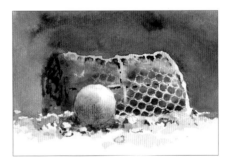

1 Liberally coat the net with a mixture of white gouache and a touch of Naples yellow to take off the stark whiteness. Place it on a piece of scrap watercolour paper covered in a fairly dark colour, and press it down with the roller. This gives an idea of how the result will appear and gets rid of the excess paint. You may need to do this more than once.

2 As soon as you are happy with the result, lay the netting over the image of the pot and roll over it; making sure that the outline of the pot, the buoy and the light foreground are masked off, and the dark background covered with paper to avoid any of the gouache spreading beyond the lobster pot.

3 The result in this instance has been reasonably effective. You may find that you need to tidy up the edges of the monoprint a little with a damp brush and tissue.

Textural effects

There are numerous ways of introducing texture into watercolour paintings, from the simple manner of brushing across a Not or Rough surface with the side of a brush, to introducing materials specifically aimed at creating textures.

After laying a wash of lightish colour (raw sienna or Naples yellow, for example) and allowing it to dry, you can apply broken colour of a darker tone with the side of the brush. As you draw it across, it will pick up the texture of the paper. You can change to the point of the brush in places to create variation as well.

I commonly spatter my work, to induce both texture and spontaneity, and this can be done by dragging your finger or thumb across the hairs of a loaded brush. If you prefer, you can use a palette knife. Spattering using a toothbrush loaded with either paint or just water works well over a damp wash that is almost dry. Spattering over a dry wash using a toothbrush, round or flat brush loaded with paint also works well. You can alternatively apply the spatter with a chopping motion, or strike the brush downwards onto a finger.

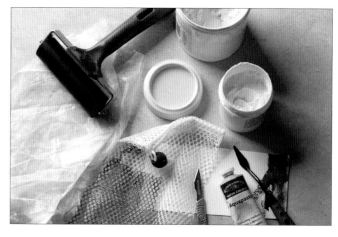

Materials for adding texture

Heavy texture can be striking but beware of over-doing the effect. I often use white Daniel Smith Watercolour Ground applied with a painting knife. Once allowed to dry overnight, you can paint over it, and this can produce exciting textures. Gesso is similar, though watercolour does not take so well. Having said that, the more unpredictable results can have a charm of their own. Schminke texture paste produces a rougher finish that can be appealing on features like rocks, cliffs, rough ground and so forth. It is best applied with a knife or piece of card. A scalpel is most effective for scratching out highlights, while the roller, netting and aquapasto pictured above are used for the technique on page 17.

The flagpole has been created by picking up white gouache on the edge of a piece of card and applying it to the boats: an effective method of getting a straight, thin mast. Make sure you test it first on a piece of spare paper, as it is likely to hold an uneven amount of paint.

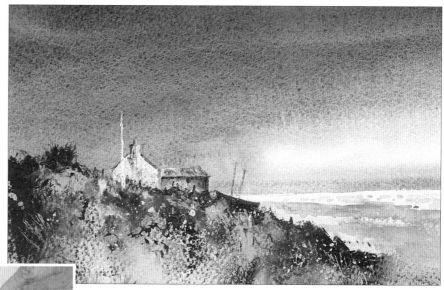

The Red Boat
23 x 12.5cm (9 x 5in) 425gsm (200lb) Not surface

After painting the sky and beach washes in the normal manner, I then used a small piece of card to apply paint, effectively working its straight edge to define the cottage with white gouache, then the dark masts and fenceposts, and finally on its side to suggest rough ground in the foreground in the style of a dry-brush (see inset). The Bockingford Not surface helped to achieve this effect. I then applied the darks with a no. 8 round brush. The final flourish was to plaster thick light green and yellow gouache in places with a few dabs here and there to indicate individual grasses with the edge of the card.

Boats at Beer, Devon
38 x 25.5cm (15 x 10in)

One of the problems of painting the beach at Beer is the heavily-contrasting cliff detail which is often overdone and spoils many a painting of this lovely scene. In this watercolour I wanted to portray the beautiful cliff scenery but place the emphasis on the boats as a centre of interest. I also wanted to portray the lovely sunlight falling on the cliffs, and after some deliberation decided to use Daniel Smith watercolour ground applied with a painting knife across the cliff area. In places I created a heavier impasto effect, varying the application throughout. The next day I began the watercolour washes, leaving white highlights in places to enhance the sense of sunlight, and playing down the strongly-contrasting vegetation which would introduce a tatty leopard-spot appearance. The overall effect formed a fine background to the boats, without being intrusive and drawing too much attention.

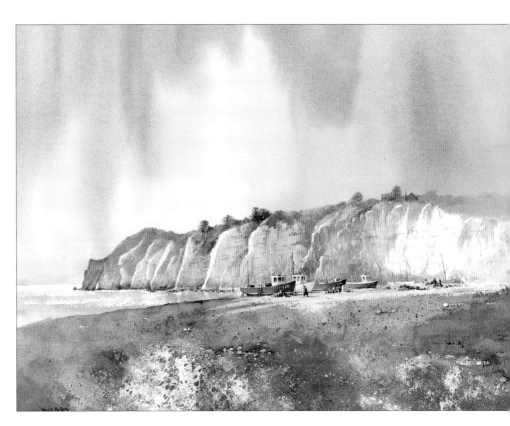

Texture paste for rocks

Here Schminke heavy texture paste was spread across the rocks with a knife (see detail below) and, when dry, painted over. This can produce striking textures in rocks, walls or ground detail, and even foliage, although it needs care where you wish to depict fissures.

The sea was painted with a scrub-and -scratch method, where the brush was held almost parallel with the paper and in line with the horizon, then with a wriggling motion dragged across the sea area, leaving white strips here and there. When the sea was dry, further highlights were scratched out with a scalpel.

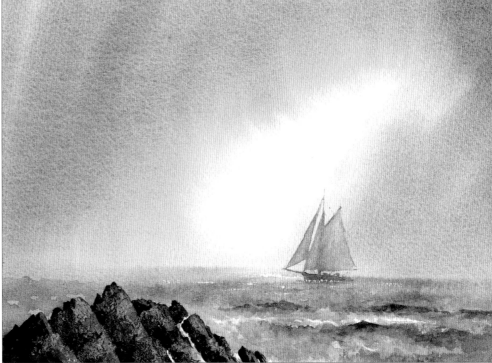

19

Coastal features

The best way of learning to paint coastal features, as with any form of landscape, is to go out and work directly from nature. It can be daunting to go forth into the great outdoors without some prior experience and, in any case, many folk are not easily able to get out. This chapter therefore is aimed at introducing you to the problems and delights of working on these fascinating subjects to give you the confidence to start.

Practise as much as you can, even if you have only ten minutes before you need to start cooking the evening meal. Being ready and organized for these spare moments can make a great difference, and you really don't need several hours of spare time to push your watercolour knowledge a little further. Keep a few pencils and a cartridge sketchbook handy for these moments and simply draw the objects around you, perhaps extending this to drawing model boats or laying simple washes of watercolour, and experimenting as in the previous chapter.

I often cover my drawings and sketches with copious notes and diagrams as in the sketch of the cod-liver oil factory below, which was a rushed affair enhanced later at base with some tonal work in pencil. Subjects like this building (below) make for an easier introduction to landscape work for the beginner because you have a definite structure before you, and it is much simpler to render than an amorphous collection of rocks, seaweed and marine detritus. That can come later when you feel more confident.

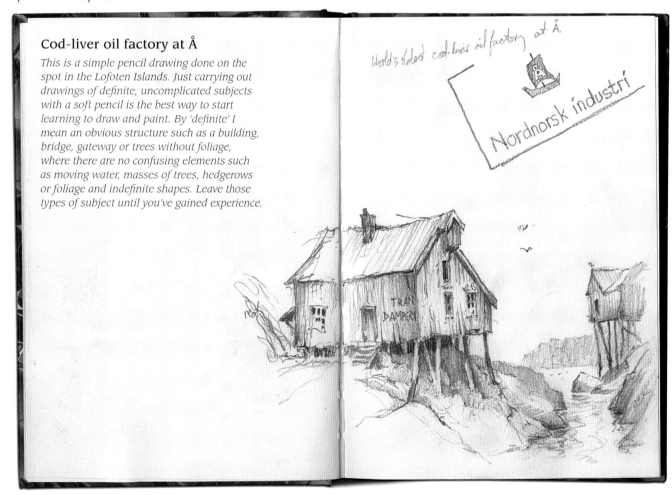

Cod-liver oil factory at Å

This is a simple pencil drawing done on the spot in the Lofoten Islands. Just carrying out drawings of definite, uncomplicated subjects with a soft pencil is the best way to start learning to draw and paint. By 'definite' I mean an obvious structure such as a building, bridge, gateway or trees without foliage, where there are no confusing elements such as moving water, masses of trees, hedgerows or foliage and indefinite shapes. Leave those types of subject until you've gained experience.

Painting cliffs

The secret to painting cliffs is to study them with a view to picking out the most prominent lines of fractures and shadow areas, how you are going to emphasize the main colours, where you will suggest most detail, and how the overall cliff is affected by tones. You need to be clear in your mind how you will approach each of these aspects before you start.

Don't try to include everything, as that will make you feel overwhelmed. Begin with a light pencil drawing, seeking out the main shapes and deciding where you will put the emphasis. If there are strong gullies and fracture lines, pick out the most interesting of these and lightly delineate the most exciting bits of detail.

When you are ready to apply colour, think about all the colours you need to paint the cliff. Prepare those mixtures plus any colours you may wish to drop into wet washes. Forget about the shadow parts for the moment.

Once you are prepared, begin applying colour washes, starting with the lightest colours. With watercolours we need to begin light and gradually work in the darker colours, overlaying these over the lighter ones in places. Drop in any additional colours – perhaps where you see a change in the rock colour – then allow the whole to dry. Once the paper is dry you can paint in the shadows. Again, wait for these to dry, then draw in the fracture lines with a fine brush or rigger, applying greater pressure to the brush where you need a wider fracture line. This is also a good time to introduce any rock detail into the cliff with a medium-size brush such as a no. 6 or 8 round.

Note that cliffs tend to be darker in tone lower down, where they get washed regularly by the sea, and you are likely to need to introduce darker tones in this area. You can do this by laying a wash of clear water over the bottom half of the cliff, and then applying the darker colour to this lower area. Do not take it right up to the top of your wash of clear water, as the intention is to achieve a soft edge to the darker area.

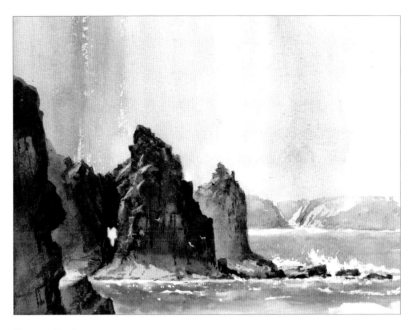

Tower Point
21.5 x 18cm (8½ x 7in)

Cliffs are complicated structures to render, but here I deliberately chose a backlit subject so that much of the detail was lost in shadow. Flecks of sunlight highlighted parts of the rocks and this slowly changed as I sketched. I've scrambled in and out of these towers at times so have a fairly intimate knowledge of the place and have thus been able to work out that the right-hand tower is separate from the rest, so I accentuated the space by lightening the right-hand tower and darkening the right-hand edge of the left-hand tower.

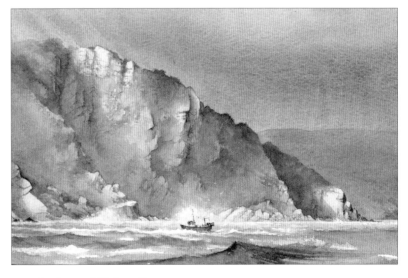

Rendering cliff detail

This is only part of a huge imperial-sized watercolour and illustrates well my three approaches to painting complicated cliff scenery. Firstly strong detail can be seen at the top left and high above the boat. There is more subdued detail directly above the boat, and no detail at all in much of the area above the diagonal rib of rocks extending forwards from the prow of the boat, and also the area to the stern, above the jumble of rocks.

Painting beaches, surf and rocks

The combination of beaches, surf and rocks can provide the artist with delightful compositions. Watch for variations in tone and colour on the sand – I often lay a wash of Naples yellow or yellow ochre and, when that has dried, overlay a colour. I use permanent alizarin crimson or another red if I feel it needs warming up – sometimes over part, sometimes whole – or a darker colour if I need a cast shadow. This can be done wet-into-wet, but it's simpler to begin by overlaying the wash on dry paper.

Note how parts of the beach are more interesting when they are wet and therefore darker. These are excellent places to emphasize the definition between beach and surf. Try to avoid having a strong, sharp surf-line all the way across a composition as this will intrude: break it up by losing it in places, or soften it off with a damp brush. You can do this while the paint is still wet or leave it until the paper is completely dry.

With surf, keep it simple. Don't try to include every nuance of tonal detail. Resist the temptation to include every mini-wave you can see. Gain your experience on gentle waves to start with, working up to massive breakers later, as described further into the book. The painting *Dunraven Bay* opposite is a good example of what to look for in a less complicated line of surf. As with the beach, it's interesting to drop in a different colour to provide a little variation in the water. Beach pools and rivulets running into the sea can add interest and break up monotonous passages, and I often introduce these from other sketches, even if they are not actually present.

Rocks tend to be a little easier than moving surf, but need care. Don't feel you have to cover every square centimetre with detail or fractures, and it is helpful to indicate a slight change in colour in places: colour changes are usually gradual, fracture lines tend to be stark. It's good to have fracture lines disappearing into shadow areas in places. There are many examples of various types and shapes of rock in this book, with a variety of treatments, so copy some of the examples that appeal to you.

Rock fractures

Rocks vary considerably in character. Here I have illustrated fracture lines using a rigger, applying different pressures on the brush to create thicker and thinner fracture lines as I require them.

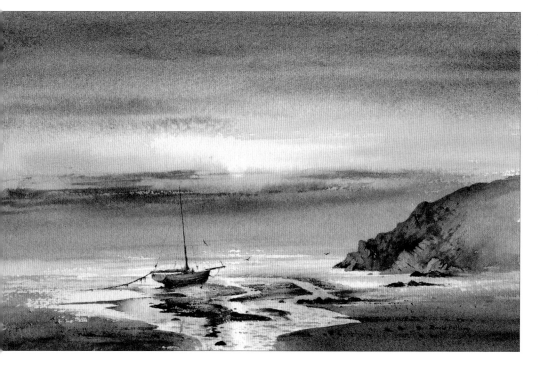

Boat at Sunset
28 x 17.5cm (11 x 7in)

I like to make the most of pools and rivulets on the beach. They can add interest, act as a lead-in, or support a focal point such as a rock or – as in this case – a shapely boat.

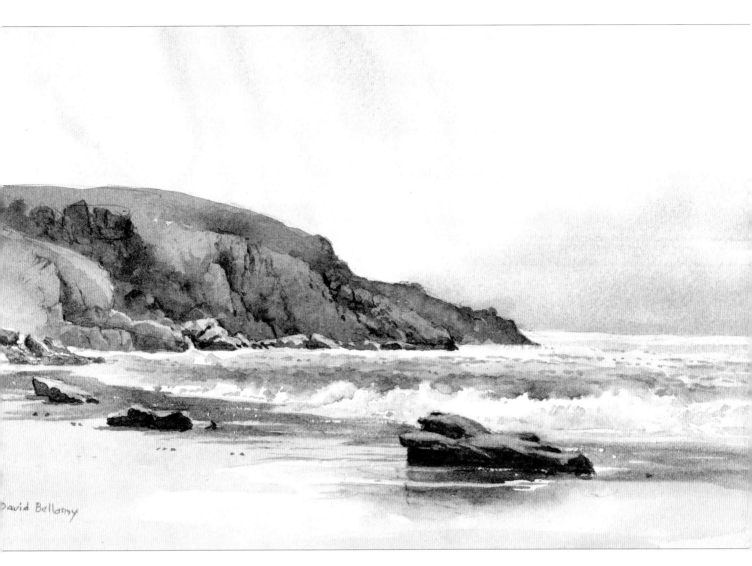

Dunraven Bay
23 x 15cm (9 x 6in)

Painting the sea can be extremely complicated, so we need to break it down into manageable chunks. In this watercolour of the beach at Dunraven Bay, the sea has been kept fairly simple: the distant water has been painted with a weak mixture of French ultramarine and cadmium red, and this is considerably strengthened as it gets closer, especially where it defines the crest of the white breaking wave. When the sea wash had dried, I dabbed in small flecks of the same mixture to suggest the rippled surface. Where the beach is wet, the sand is darker, again defining the edge of the surf. I have deliberately softened off the edges of both the wave-tops and the surf in places to suggest a more natural look.

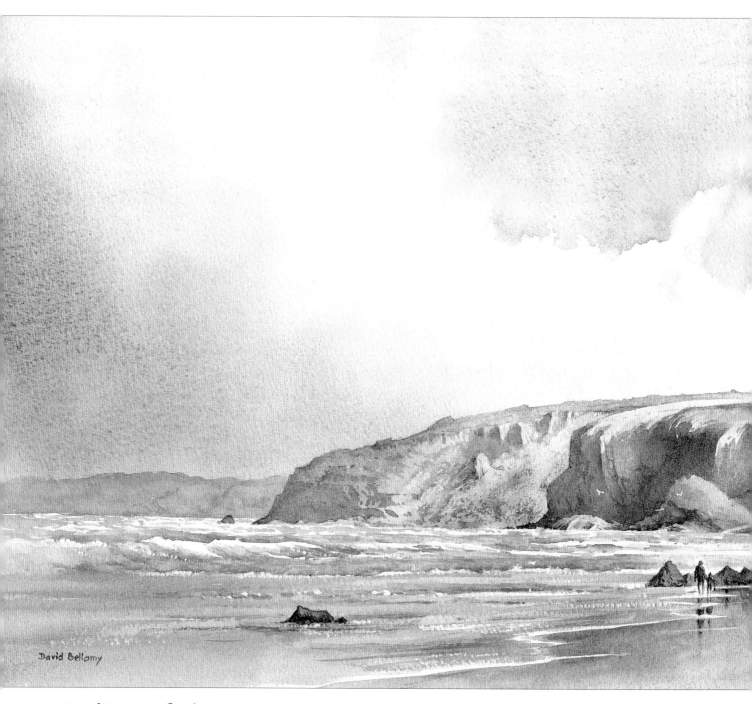

Broad Haven Reflections
43 x 28cm (17 x 11in)

Although I carried out an original sketch I also spent some time waiting for people (often with their dogs) to come wading through the wet surface of the beach; I then photographed them and did quick pencil sketches, concentrating on the figures and their reflections. I did this from a distance to avoid causing any concerns. The reflections were achieved by laying a wash of cobalt blue and cadmium red between surf and sand, and dropping in the rock and figure colours wet into wet.

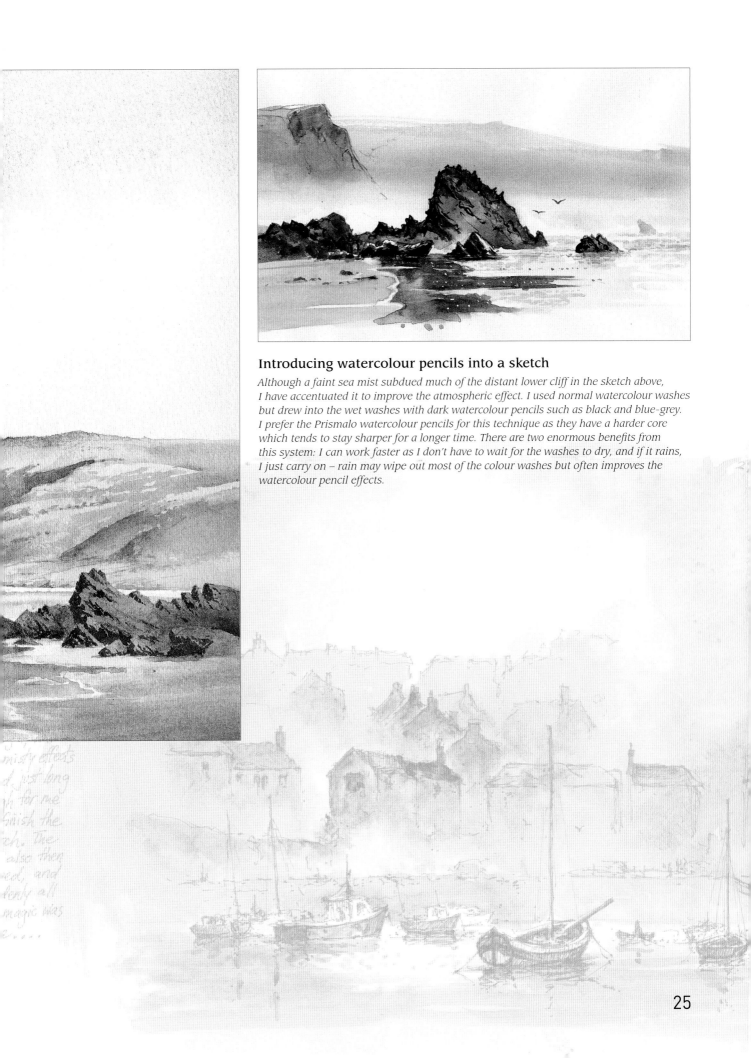

Introducing watercolour pencils into a sketch

Although a faint sea mist subdued much of the distant lower cliff in the sketch above, I have accentuated it to improve the atmospheric effect. I used normal watercolour washes but drew into the wet washes with dark watercolour pencils such as black and blue-grey. I prefer the Prismalo watercolour pencils for this technique as they have a harder core which tends to stay sharper for a longer time. There are two enormous benefits from this system: I can work faster as I don't have to wait for the washes to dry, and if it rains, I just carry on – rain may wipe out most of the colour washes but often improves the watercolour pencil effects.

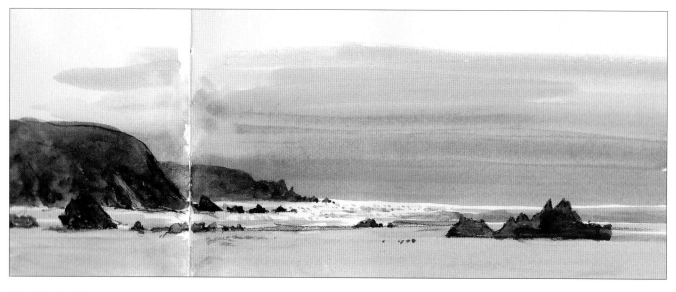

Gentle Surf

Often there are not any distinctive waves, as in this simple watercolour sketch on cartridge paper. Here the small waves have been suggested by horizontal strokes of a no. 10 round brush plus a few little blobs to impart a sense of movement and sparkle, leaving white streaks with a horizontal emphasis.

Softening off some of the edges creates a better sense of movement and varies the wave structure.

Strong contrast and a sharp line are necessary for at least part of the top of the wave to give it strong definition.

Make the most of peaks in the waves, as these can break up a monotonous line and act as the focal point.

The breaking wave is thinnest at this point, allowing background light to shimmer through, and adding considerable interest.

As the wave curls over, it creates a shadow underneath.

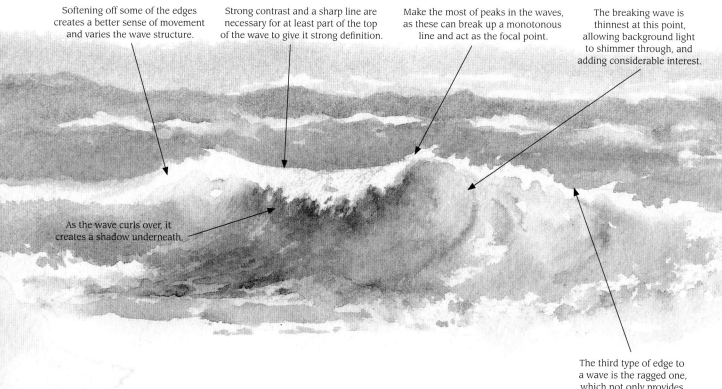

The third type of edge to a wave is the ragged one, which not only provides variation, but increases the feeling of movement.

Wave structure

This shows the basic structure of a breaking wave. Wave structures can vary considerably and it is helpful to carry out many studies of different types of waves while you are on the spot. Don't rely entirely on the camera. This is a fairly typical wave as it breaks. As it curls over, a shadow is created beneath the crest, which at this point usually stands out prominently against the background. At the same time, as the wave extends upwards, the wall of water becomes thinner, enabling a translucent light to pass through, often quite bright when lit from behind.

Painting waves

Waves vary from minor ripples to monstrous walls of water. We begin with a gentle surf sketch (see opposite, top) which can introduce an air of tranquillity to a scene. We then move on to analyse the structure of a more complicated wave as it breaks onto the beach (see opposite, bottom). This kind of wave can act as the focal point for the whole composition and can have endless variations in colour, size, shape and tone. Work from these examples so that by the time it comes to sketching them directly on the spot you are better placed to render the structure of many kinds of wave.

In strong winds the waves not only seem larger, but often spindrift is blown sideways over the top of the wave as you will see in the example of *Windy Day, Barafundle Bay* (see below). As this is more complicated, you may wish to postpone working on this type of wave for now and come back to it when you are more adept at the techniques involved.

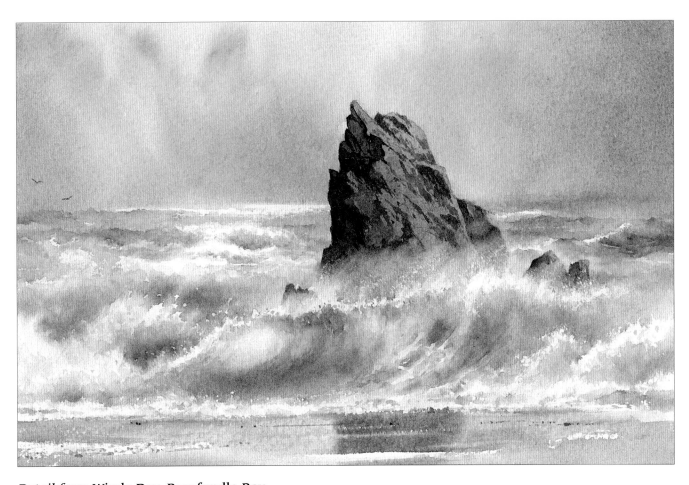

Detail from Windy Day, Barafundle Bay

This concentrates on the central part of the painting where the wind is catching the crest of the wave and hurling spray to the right. This effect was achieved by pulling out colour diagonally upwards from the crest of the wave using a 12mm (½in) flat brush. When the area directly above the wave had dried, I scratched out suggestions of blown spray with a scalpel.

Interaction of rocks and sea

This is one of my favourite subjects, especially when wild Atlantic breakers are hammering the coastline. Water draining off a large rock can be a complicated – but evocative – subject.

Avoid putting in every minor rivulet cascading down the rock, and instead concentrate on the outstanding ones, noting where they fall into a shadow area. At these points I lay on a weak shadow colour with French ultramarine or cobalt blue, sometimes touching in a little permanent alizarin crimson in order to pick out these details.

Always ensure that you have plenty of white cascading water present, by leaving that part of the paper untouched: these areas form the highlights. The next stage is to introduce the dark wet rocks, in each case softening off their bottom edges where they disappear into the water. Finally, note foaming water at the bottom of the mass of rock, and where the edge gets lost in places.

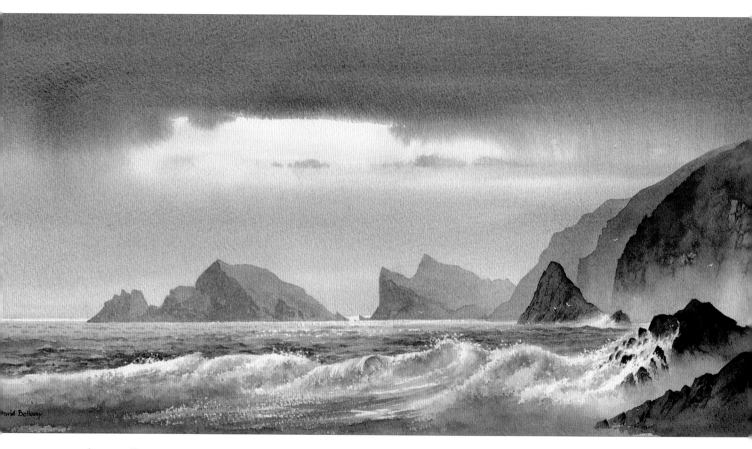

Rocky Anvils
46 x 23cm (18 x 9in)

The sparkling white spots below the great rocky anvils were achieved by using masking fluid immediately after completing the drawing. I spotted this on with a small brush, taking care to clean the brush off well with warm soapy water afterwards, as masking fluid can quickly ruin brushes. When the fluid was dry, I painted over it with a light blue-grey wash.

For the water draining off the foreground rocks, I first painted in the light blue-grey shadowy part of the falling water, leaving the tops mainly as untouched white paper. When this had dried, I described the strong dark rocks with a mixture of burnt umber and French ultramarine.

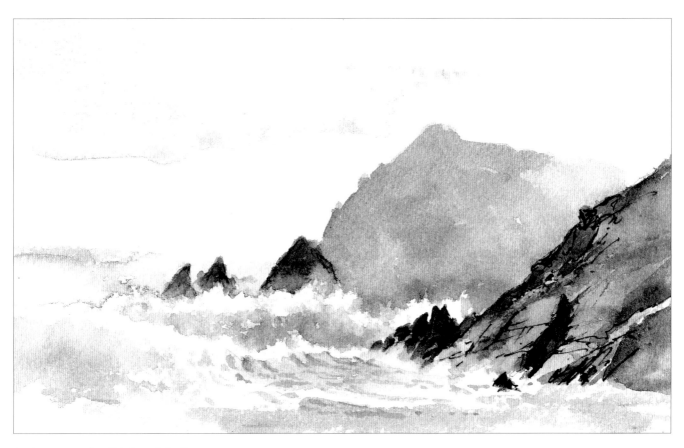

Boisterous Surf, Westdale Bay
21.5 x 17.5cm (8½ x 7in)

In this watercolour sketch, the water was more complicated than in Rocky Anvils opposite, but even so I have simplified it considerably from the actual scene. Much of the wave-top area has been described using the side of a round brush in semi-circular sweeps to suggest the choppiness. See how dropping a touch of yellow ochre into the wet sea wash below the central triangular rock has enhanced the wave, and the darkest jagged rocks are emphasized by the white splash behind them.

Interaction of rocks and sea

For this sketch I used a 4B pencil and to achieve the soft-edged splashes I pulled out the graphite with a fine pencil-eraser. Careful observation of the way the sea hits the rocks is vital. The repetitive nature of the waves helps you to observe time after time how best to render the various actions and movements. Videoing the action can be helpful.

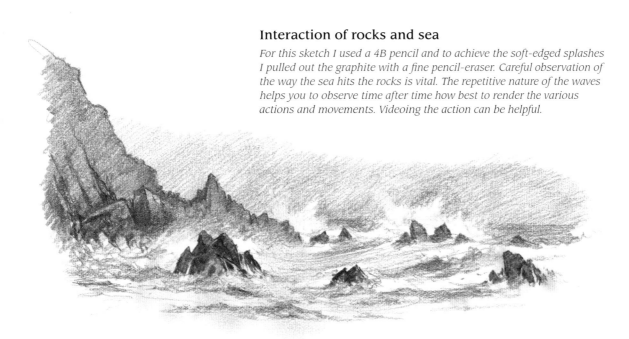

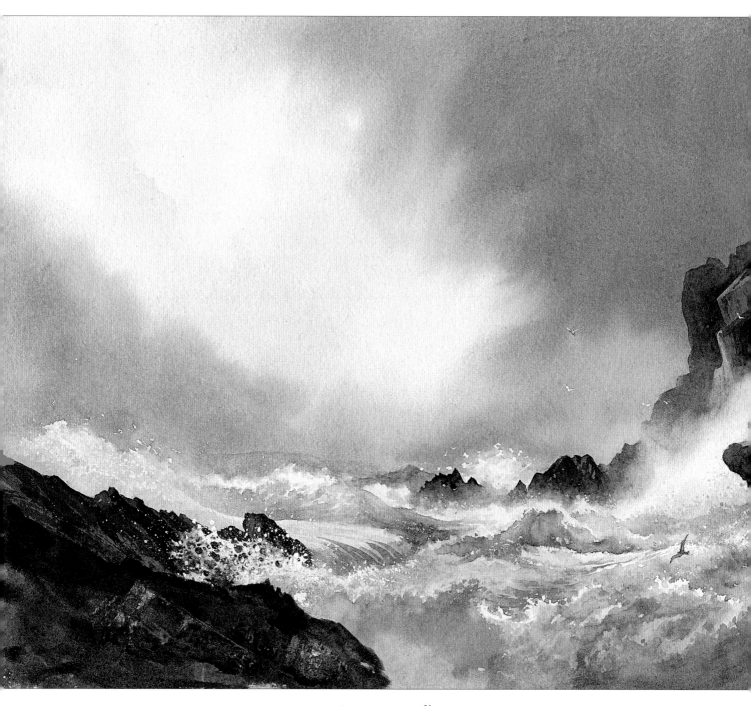

Stormy Coastline
40.5 x 30.5cm (16 x 12in) 300gsm (140lb) Rough paper

Creating whites in turbulent seas can be a challenge, but there are several ways of achieving this, as shown in this watercolour carried out on Saunders Waterford Rough paper. On the left I produced a splash by dabbing a sponge in white gouache and applying it to a dark background. Here and there I have stabbed and scratched with a scalpel to suggest white foam – this is most evident below the right-hand rocks to the right of the gull. The white areas were left as the white paper by working around them with colour.

Capturing the whites

Where rocks and sea meet there is generally a lot of white surf, spray and splashes, and these can be tackled in numerous ways. In some of these examples I have included a variety of techniques to achieve these whites, as they can add so much life and movement to a scene. Try them all and see which ones suit you best: masking fluid, scratching with a scalpel, white gouache or acrylic, negatively painting round a white object and leaving the paper white, or even rubbing a candle across the water to act as a resist. This latter method is more of a hit and miss affair, but can be effective.

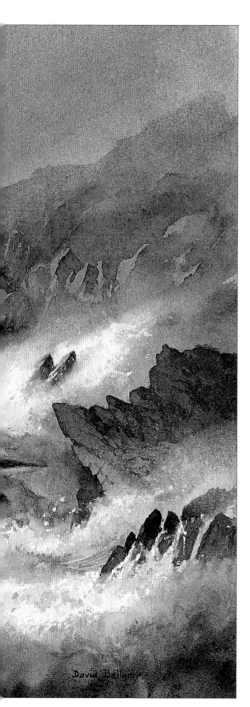

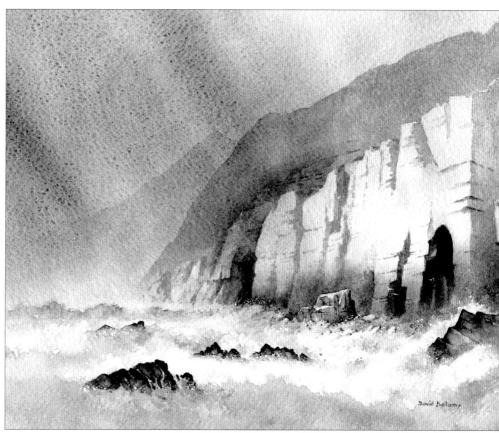

Wave-lashed Cliffs
28 x 23cm (11 x 9in) 300gsm (140lb) Rough paper

The darker tones of the lower part of the cliffs helps to accentuate the white foaming surf as it crashes against the rocks, and the final stage of this painting was to scratch out splashes at the top of the surf with a scalpel, mainly using a diagonal stroke to suggest movement towards the cliffs. Some of these strokes half-obliterate rock detail effectively. The textures were enhanced by using a Saunders Waterford Rough watercolour paper surface.

Drawing and painting boats

Boats can cause a lot of teeth-gnashing, especially if you are trying to draw an example with voluptuous curves, as you often see in the Mediterranean. If you are not happy including boats, but they are vital to the scene, then keep them simple – the further away they are, the better! Draw them broadside-on, which is the simplest profile. Break them up with figures working in front of them or with draped nets, tarpaulins or other marine clutter.

 Usually in a harbour scene there are different types of boats, so go for the easier ones and move them into positions where you can lose certain parts of the vessel. You can lose detail in boats through judicious positioning and effective use of light and shadow. There are further ways of tackling boats in the chapter on a day by the sea, when you are actually confronted by them.

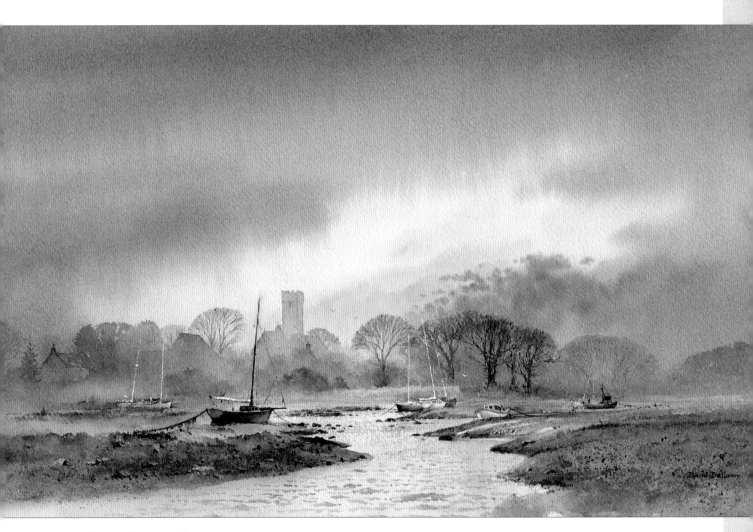

April Evening, Angle
43 x 20.5cm (17 x 8in)

These boats are fairly easy to draw when they are broadside-on. Where you have several boats, it pays to overlap some otherwise the composition may well appear contrived. Note the reflected light on the forward part of the hull of the closest vessel.

Drawing boats using a box

This is a relatively complex approach, useful for boats lying on one side. The secret is to work out the important lines and angles first.

There is no need to draw a complete box structure, and as you gain experience, you will find you need less of the construction process. Make sure the construction lines are faint and can be easily erased.

1 The rudder line is important as it indicates the angle at which the boat lies, and also the line of the mast and other verticals, such as those of a cabin. Hold a pencil vertically against the rudder line to assess the initial angle.

2 Add the mast, making sure that it is parallel to the rudder.

3 Draw line B–C at 90° to the rudder line and estimate its width by comparing it with the height of the boat.

4 Establish the parallel horizontal construction lines and the length of the boat.

5 Points D and E are approximately halfway along the boat and show where the hull would appear if it was straight along. However, as the hull normally curves outwards at this point, points F and G are approximations of where the hull would actually appear.

Tip

Cabins can have a forward, backward or sideways rake, but just as with the mast, the line of the rudder will always help to assess this.

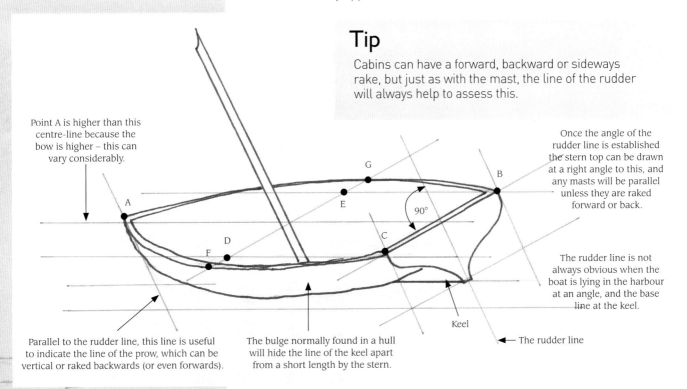

Point A is higher than this centre-line because the bow is higher – this can vary considerably.

Once the angle of the rudder line is established the stern top can be drawn at a right angle to this, and any masts will be parallel unless they are raked forward or back.

The rudder line is not always obvious when the boat is lying in the harbour at an angle, and the base line at the keel.

90°

Keel

← The rudder line

Parallel to the rudder line, this line is useful to indicate the line of the prow, which can be vertical or raked backwards (or even forwards).

The bulge normally found in a hull will hide the line of the keel apart from a short length by the stern.

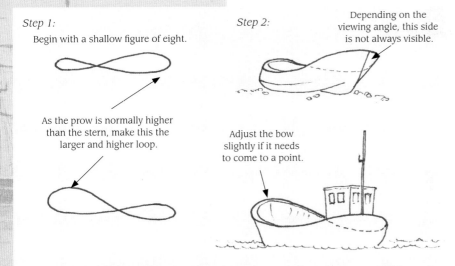

Step 1:
Begin with a shallow figure of eight.

As the prow is normally higher than the stern, make this the larger and higher loop.

Step 2:

Depending on the viewing angle, this side is not always visible.

Adjust the bow slightly if it needs to come to a point.

Drawing boats using a figure-of-eight

This method is useful in some cases but is rather limited and does not suit all boats. It can be a useful guide when trying to render the graceful curves of small boats.

The stern can easily be changed from the round version shown in this example, to one with a square end.

Drawing boats using a model

Working from a model boat which has fairly authentic lines can be an excellent way to practice drawing boats. You can place the model on a pile of books, adding to the pile or removing books as you need to change the viewing height, as well as moving the model around for different viewing angles. Illuminating it with a desk lamp from a variety of positions is also effective.

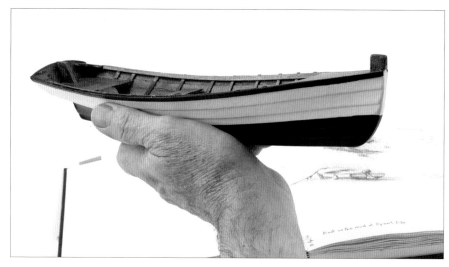

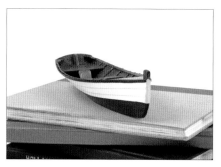
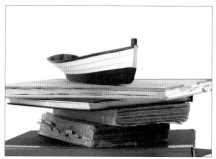
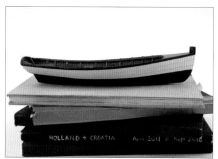

So long as the model has faithful curving lines, it will give you excellent practice as you can move it around to different angles as well as raise or lower it for a new vertical perspective.

Rigging and sails, using French curves

Don't forget the ropes and chains, as these can add handsome curves in a composition dominated by straight harbour walls and buildings, and can also be used as a lead-in to the focal point. French curves, which are plastic templates that describe various curves, are ideal for this.

1 With the bulk of the boat drawn, load a no. 6 brush with a dark mix – burnt umber and indigo in this example – and draw it across the dip pen nib.

2 Place the French curve in place on the surface, and draw down the side of it, then lift the curve away (see inset). This is effective when there are several lines of rigging blown into parallel curves by the wind.

This detail, from Los Gigantes *(see page 85), shows parallel curved lines of rigging running up from the bowsprit. Note the sailor sitting working on the foremost yard.*

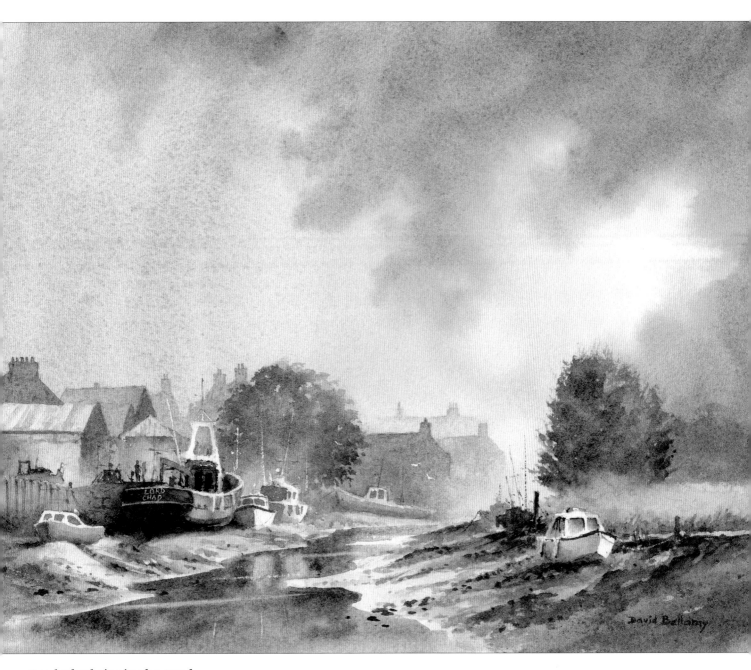

Lord Chad sits in the mud
25.5 x 20.5cm (10 x 8in)

Describing every feature in great detail is not usually helpful in a painting. Losing parts of the fishing boat in dark shadow – as in Lord Chad's bottom in this watercolour – can create a more effective impression. On the right the two boats described mainly in tones work well against thc light. Note how the closer one is both darker and has more colour.

Boaty Bits

Drawing a diagram of a boat while it sits in front of you is an excellent way to gain an understanding of its various features such as rigging, masts and so on.

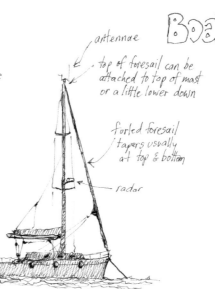

antennae

top of foresail can be attached to top of mast or a little lower down

furled foresail tapers usually at top & bottom

radar

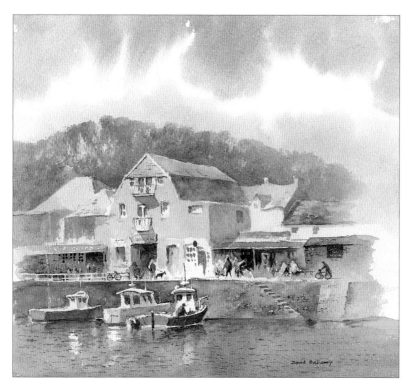

Painting harbours

It is easy to over-work harbour scenes, as there is usually so much happening. Try to reduce excess detail by simplifying parts of the scene, perhaps bringing in smoke, haze or mist, or employing strong backlighting to induce mood. Concentrate on one area where there is a strong focal point, and add figures to support it. Figures can be suggested rather than carefully described, and they can be used to hide architectural or marine detail behind them. Suggest any reflections instead of painting in crystal-clear mirror reflections that can overwhelm the eye. When we view a scene our eye is selective about what it takes in − peripheral vision indicates that something is present just beyond where we are focussing our gaze, but it is vague. To include all this as strong information that can be viewed easily as a complete picture is simply too much − we need quiet, uncluttered parts in our paintings.

Padstow Harbour is more cluttered than I like and was done as an alfresco demonstration on a course. Everything was clearly visible, so I had much to leave out and subdue, but even so I would have preferred to omit more. In the Torquay watercolour, though, nature conspired to provide sufficient mist to eliminate most of the background but leave sufficient for me to suggest the setting. Hastings does not have a conventional harbour, so the boats are hauled up the beach. This allowed a simpler image than would otherwise be the case.

Padstow Harbour
20.5 x 20.5cm (8 x 8in) 300gsm (140lb) Not surface

This was an alfresco demonstration for a course where I was keen to emphasize the sense of strong sunshine by featuring many white areas juxtaposed against darker shadows on boats and buildings. As there was quite a lot of detail involved I painted on Saunders Waterford Not. The reflections are minimal as there was a slight breeze, and these were achieved by working in the darker parts negatively around the white cabin reflections, and then painting in the darker hull and rudder post reflections. I generally prefer to work in reflections with the wet into wet method, but show this as an alternative example.

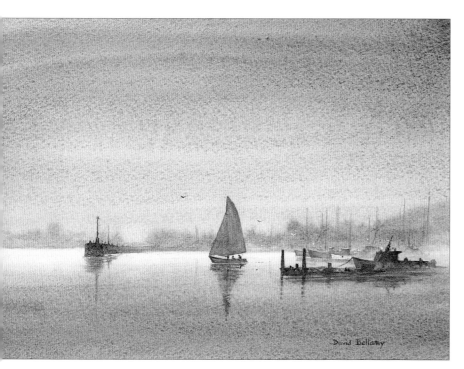

Evening Mist, Torquay
28 x 18cm (11 x 7in)

The mist was welcome, as it obliterated much of the background detail. The suggestion of the soft-edged background detail was done with the wet into wet technique, firstly by laying on the sky wash and then, after waiting a minute or two, applying a stronger mixture of the same colour to indicate vague buildings and vessels. When the stronger detail was painted onto dry paper later, this provided a strong sense of depth to the work. The reflections were painted again wet into wet once the sea wash had begun to dry. Often you will need to adjust shapes to conform to reality, and you can do this immediately with a slightly damp brush without any paint to take out part of an edge.

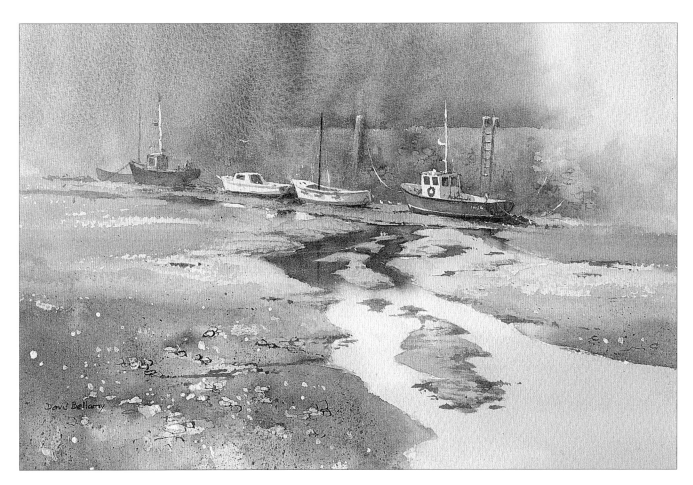

Boats at Low Tide
25.5 x 18cm (10 x 7in)

Harbours at low tide offer you great opportunities for taking advantage of water channels, chains, ropes, buoys and similar details to use creatively. Pools of water or channels as in this scene can provide reflections, act as a lead-in or break up large expanses of mud, and you can happily position them where it suits you best.

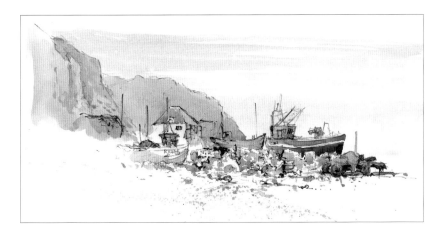

Harbour detritus at Hastings

Where there is a lot of jumbled-up detritus as in this sketch, where lobster pots, fish-boxes, plastic drums, ropes, nets, buoys and even a rusty caterpillar tractor litter the place, it can help to turn all this into an abstract or semi-abstract passage within the overall composition. In this way you can be extremely creative with your shapes and colours, and it's worth trying out various combinations on scrap paper before deciding how to tackle the finished painting. Needless to say, I thoroughly enjoyed working on this heap of 'rubbish'.

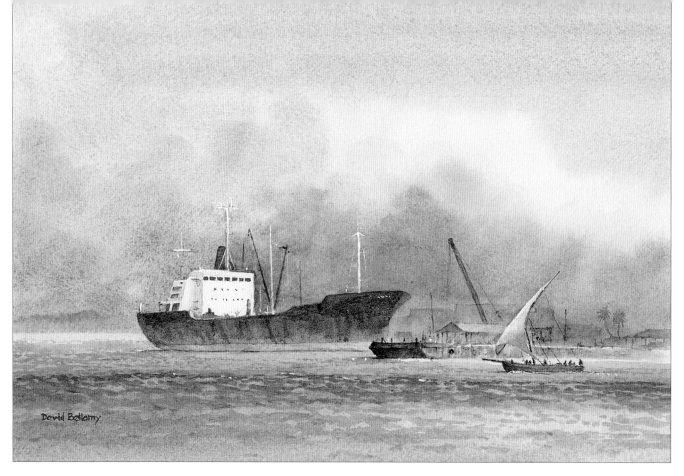

David Bellamy

Linear perspective and scale

In a harbour, it is hard to avoid the effects of linear perspective, and often it is right on top of you, which tends to accentuate the problems. While it is vital to have a fair idea of how the perspective is affected by your viewing position, it is not worth losing sleep over the matter.

Firstly establish where your eye level appears: Typically, this is usually around two-thirds of the way up a door. This depends on your height, of course – the eye level changes if you climb up or down steps or a slope, or even simply sit down.

The main thing to remember is that any horizontal lines that appear above your eye level will run downwards as they get further away from you, and those below your eye level run upwards as they run away from you, so it is important to work out the nearest point of those lines before you begin drawing.

These lines eventually meet at a vanishing point which stands on your eye level line, often way off the paper. To work out the angle of the slope of a feature (such as the line of a roof, or the line of a ship's deck), hold your pencil horizontally at arm's length, with one eye closed and the pencil appearing to 'rest' on one end of the line you are interested in drawing. This is a rough guide but will give you a fair idea of not just which way the line is falling, but also the degree of the angle at which it is falling. This is useful to compare with other similar lines which might be higher or lower. The further away the line gets from your eye line, the more acute the angle becomes. My main example here is that of a large ship, but the same rules apply to buildings.

While we are on the subject of size and shape, it is useful to consider how scale affects the scene. Including a small object will make the larger one so much bigger, and it is also good to slightly overlap these if possible, though it is not vital.

Zanzibar Berth
28 x 18cm (11 x 7in) 640gsm (300lb) Not paper

It is especially important to get the perspective right with large ships, and the same principles apply here as when drawing a building.

Here the eye level is only slightly above the waterline, so as the hull recedes towards the stern of the vessel the line of the decks goes down towards the left, each meeting at a vanishing point well off the left-hand edge of the painting. Conversely, the front top of the superstructure recedes towards the right, so this goes down to another vanishing point (not shown) away to the right of the painting.

I used a Not surface for this painting. The small dhow on the right is several hundred metres closer than the ship, but is still dwarfed in comparison: positioning a smaller object near a large one will enhance to sense of size of the former.

Zanzibar Berth perspective diagram

This shows the two-point perspective applied to the painting of the large ship, and is equally applicable to buildings. As you can see, the actual vanishing point, which is always found on the eye level, occurs well off to the left of the painting.

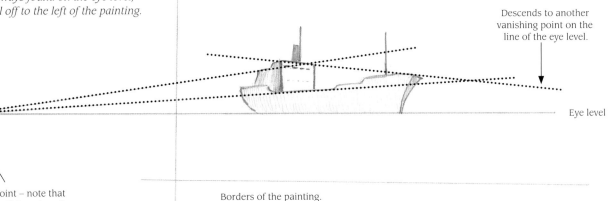

Descends to another vanishing point on the line of the eye level.

Eye level

Vanishing point – note that this is way off the edge of the painting itself.

Borders of the painting.

Comparing sizes of features

Measure the length of a vessel with a pencil held at arm's length and one eye closed. Here, the top of the pencil corresponds to the bow and the stern is indicated by the tip of the thumbnail. Holding the pencil thus, turn it 90° to check how many boat-lengths equal the height of the mast – almost one and a half times here.

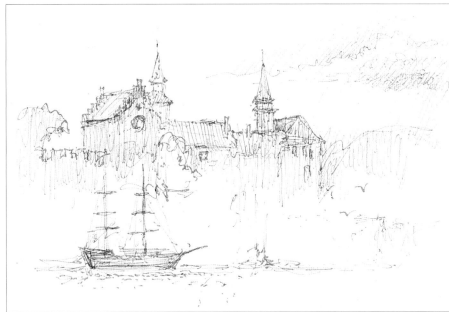

Oslo harbour sketch

This is a sketch done in ink on the back of a menu while eating out by the quayside. The lines of the two roofs on the outside of both spires descend as they recede to the left in each case. The closer you are to the building, the more acute the angle of descent becomes.

As it is impractical to go around with sketchbooks several feet long, not to mention set squares and T-squares, trying to fathom out these angles of perspective using vanishing points that would normally extend way over the page of a normal sketchbook, we need to use careful observation to record these subtle angles. A pencil held horizontally at arm's length with one eye closed will give you a fair idea of which way the feature line is angled, and also the approximate degree of that angle. It is not absolutely precise, but will serve you well in this often perplexing situation.

Maidenhall Point

In this demonstration the aim is to concentrate on the beach and cliffs. I illustrate methods to make the beach look wet in part, employing reflections to achieve this, while keeping the surf simple. You will also see that part of the cliff scenery is in detail, but much of it largely devoid of interest. You may wish to leave out the far left-hand cliff detail and the distant path climbing the hill in order to concentrate on the more important aspects of the scene.

Materials used

Saunders Waterford 640gsm (300lb) Rough watercolour paper

Brushes: Large squirrel mop; no. 10 round; 12mm (½in) flat synthetic; 6mm (¼in) flat synthetic; no. 3 round; no. 6 round; no. 1 round; no. 1 rigger

Colours: Moonglow; cerulean blue; Naples yellow; alizarin crimson; lemon yellow; green apatite genuine; quinacridone gold; yellow ochre; permanent orange; raw sienna; transparent red oxide; phthalocyanine blue; French ultramarine; burnt umber; burnt sienna

3B pencil

Sponge

White gouache

The initial sketch

1 Set your board up at a gentle angle and secure your paper to the board with bulldog clips. Referring to your sketch, use a 3B pencil to draw out the scene. Prepare the following colours: moonglow, cerulean blue and Naples yellow.

2 Wet the whole sky area with clean water using the squirrel hair mop brush. Using the no. 10 round brush, drop in areas of cerulean blue, creating soft-edged cloud forms through negative painting. Rinse the brush and add Naples yellow wet into wet into the bottom part of the sky. Soften the edge away with clean water.

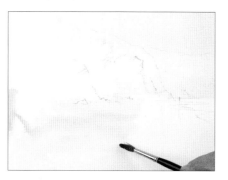

3 Add more Naples yellow behind the figure, then work some Naples yellow down over the dry beach area. Add a hint of alizarin crimson to the Naples yellow. Allow the whole painting to dry completely.

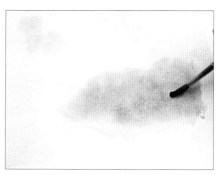

4 Re-wet an area of the sky halfway down the composition on the right-hand side. Still using the no. 10 round brush, touch in moonglow to create a darker cloud, staying well within the wet area – this is important to keep the shapes soft-edged and avoid any hard lines. Strengthen the base of the dark cloud with more moonglow added wet into wet, then soften off the bottom with clean water.

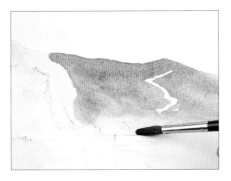 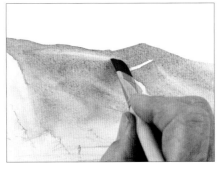 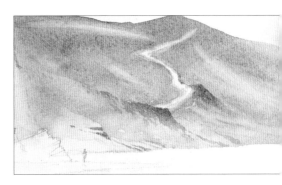

5 Make a light green mix of lemon yellow and green apatite genuine and use it to paint in the hillside on the left-hand side. Create a grey-green mix from French ultramarine and green apatite genuine and paint in the distant central area.

6 While the paint remains wet, lift out some marks that suggest the topography of the hill with the 12mm (½in) flat synthetic brush. Gently agitate the paint on the edges of the path to soften it.

7 Begin to hint at rocks at the base of the central area using the no. 3 round brush and a dilute mix of burnt umber and French ultramarine. Vary the colour by adding more grey-green or moonglow.

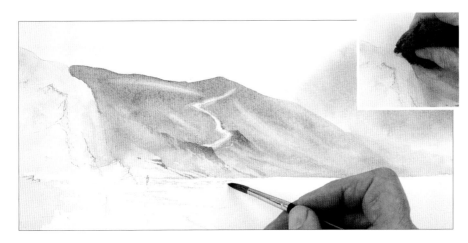

8 Use very dilute lemon yellow to glaze the right-hand side of the area, giving it a little lift to contrast with the deep storm cloud. Begin to paint the distant surf behind the figure using French ultramarine slightly muted with a touch of burnt umber. Still using the no. 6 brush, apply the mix with light, inquisitive motions. Wet a sponge and gently dab the area where the darker ridge goes behind the lighter one. Dab the wetted paint with kitchen paper to lift out and soften the area (see inset).

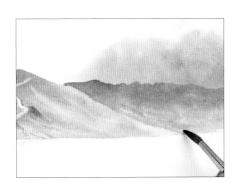 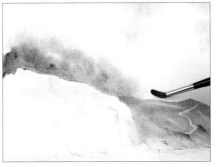

9 Using the no. 10 round brush, glaze the top of the ridge with dilute lemon yellow, then prepare a dark mix of French ultramarine and burnt umber and paint the most distant ridge. As the brush begins to run out of paint, drag the brush lightly over the edge of the adjacent area to soften the transition with broken marks.

10 Re-wet the sky using the large squirrel mop brush, then pick up moonglow on the no. 10 round and paint another dark cloud on the left-hand side, being careful not to work over the top of the ridge.

11 Add quinacridone gold behind the figure (bottom left of image) to warm the area and draw the eye, applying the colour with the no. 6 round. Work along the waterline, warming the base of the hills.

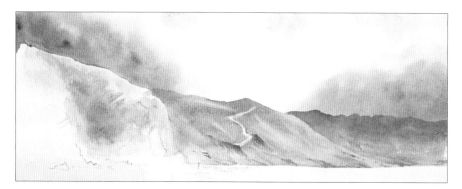

12 Mix moonglow and green apatite genuine to make a dull green. Use this to create a shadow area on the foreground hill. Deepen the mix with more moonglow wet into wet to create darker shadows, then allow to dry.

13 Still using the no. 6 round brush, paint the left-most crag with French ultramarine, then add yellow ochre wet into wet. Do the same for the rocks in the centre, then allow to dry.

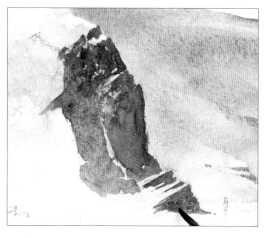

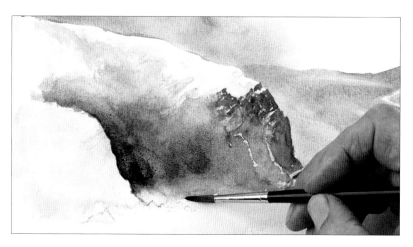

14 Add dark tones to the foreground cliff with the no. 6 round brush and a dark mix of French ultramarine and burnt umber. Work carefully, aiming to capture the angular character of the rock. Using strong darks here is necessary to create the deep shadows of the cliff. Change to the no. 3 round brush and build up the strongest tone around the focal point of the figure.

15 Continue to build up and develop the dark tones around the foreground, changing to the no. 6 round brush for areas away from the focal point. Introduce moonglow to warm the area, and a little water near the sand, in order to lighten the base of the cliff – this will help the dark rocks in front to stand out. Using a more dilute version of the same mix, bring soft shadow over the left-hand part of the grassy area, and more broken, linear shadow into the left-most cliff. Change to the no. 3 round brush and build more subtle detail into the dark cliffs, being careful not to overwork them.

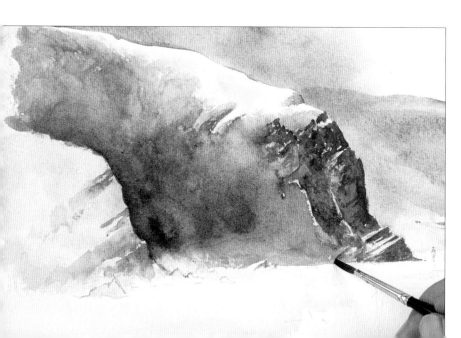

16 Strengthen the dark mix with more French ultramarine and burnt umber, and use the tip of the no. 3 brush to detail the rocks on the beach. Leave highlights on the top edges.

17 Using permanent orange and the no. 3 brush, paint the figure's coat. While wet, add moonglow for her trousers; and raw sienna for her head.

18 Draw the side of the no. 6 brush, lightly loaded with French ultramarine, over the surface of the distant water, grazing the texture of the paper with a dry-brush technique. Add phthalocyanine blue in the same way on the right-hand side, further out to sea.

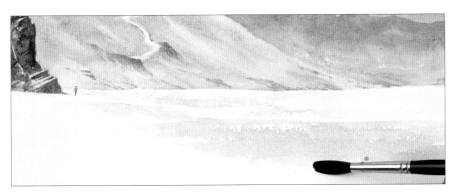

19 Work forwards with French ultramarine, building up the colour on the sea and changing to the no. 10 brush for the foremost water.

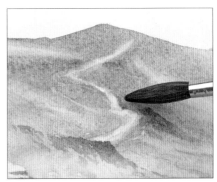

20 Still using the no. 10 brush, subdue the path a little by glazing it with a very pale grey mix of French ultramarine and burnt umber.

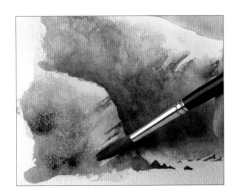

21 One technique I like to use is to drop a brighter colour into a pale grey. Glaze the left-hand rock with the same pale grey mix, dragging the side of the brush to break any hard lines, then, while the paint is wet, drop in transparent red oxide.

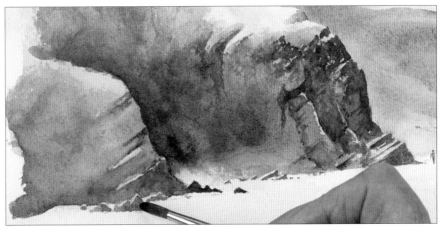

22 Change to the no. 6 round brush and use a slightly stronger grey mix to pick out a few details on the rocks and cliffs. Pay attention to the strata of the rocks, so that the lines appear natural. Add a few mossy dots of green apatite genuine.

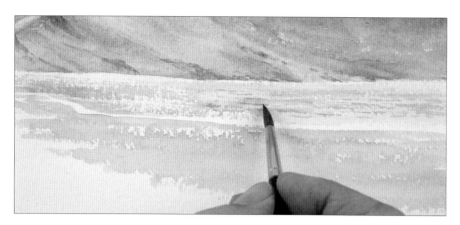

23 Preserving the white edges of the water, begin to pick out the darker areas of the water to contrast with the white surf as it comes in. Use the tip of the no. 6 brush and a pale mix of cadmium red medium hue and French ultramarine. Once the marks are in place, lightly draw the dry brush over the top in horizontal strokes to give a sense of the ripples on the surface.

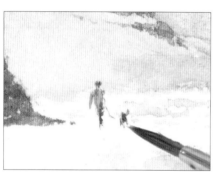

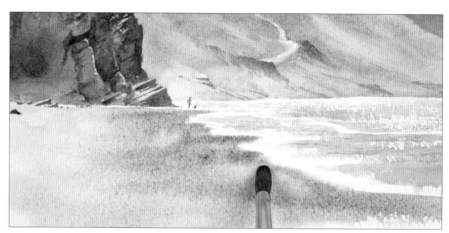

24 Use a no. 1 round and the dark mix to hint at a distant dog. Make the lead a simple curve that does not touch either the figure or the dog: leave gaps. If you make the lead too descriptive, it becomes over-laboured; better to suggest some highlights by simply leaving space.

25 Use a no. 10 to wet the whole beach area with clean water, leaving a hard edge by the surf. Lay a pale version of the dark mix (French ultramarine and burnt sienna) into the wet surface. Work right up into the hard edge. Working wet into wet, reinforce the leading edge with more of the dark mix.

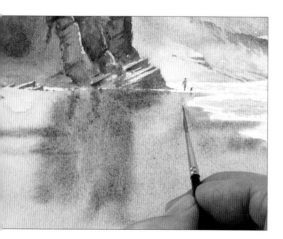

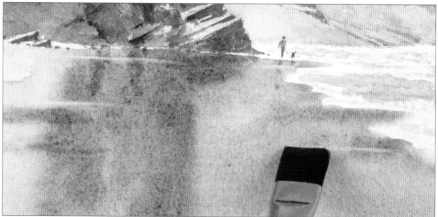

26 Still using the dark mix, add some vertical marks beneath the cliffs, as reflection. Change to the no. 1 brush and add some quinacridone gold beneath the figure.

27 While the paint on the beach dries, you can add more details into the reflections of the figure and dog using permanent orange and burnt umber and they will soften in slightly, but remain visible. Stop adding before the paint dries too much, or the reflections will look too strong. Before the paint dries completely, draw the blade of the 12mm (½in) synthetic flat horizontally across the surface, as shown, to lift out some highlights.

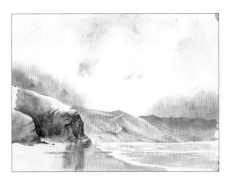 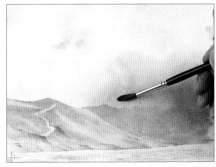 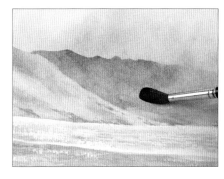

28 To strengthen the sky, wet the area (avoiding the clouds) with clean water and the no. 10, then add cerulean blue. Aim to create harder edges at the lower edges, to bring the cloud out through negative painting. However, before the area dries, soften the edge a little with a clean, dry no. 6 brush or a damp sponge.

29 Warm the bottom part of the sky with the no. 10 round brush and dilute yellow ochre, then add Naples yellow wet into wet. Add some warmer hints with a mix of yellow ochre and alizarin crimson.

30 Make any adjustments you wish. I used the no. 10 brush and a mix of French ultramarine and light red to slightly strengthen the distant ridge on the right-hand side. I also used white gouache straight from the tube to hint at a few seagulls in front of the dark areas of the rock face. Use the no. 1 rigger to paint them in.

The finished painting

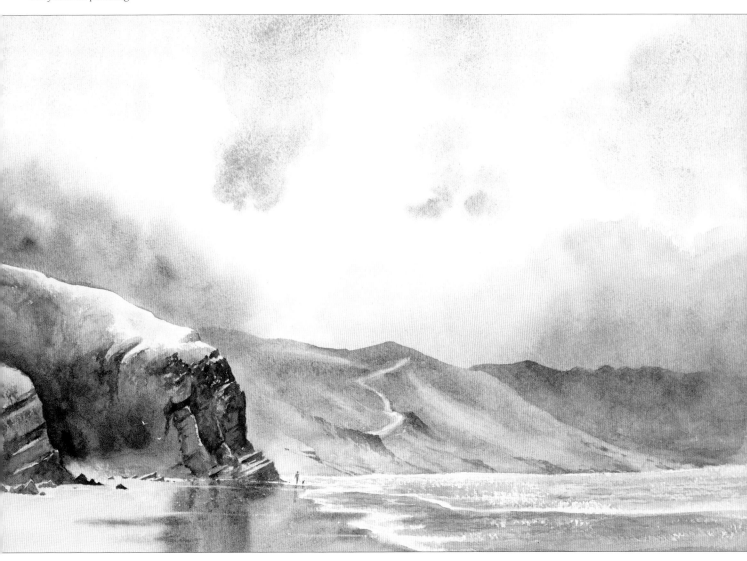

A day by the sea

By now you should have a fair idea about how to tackle some of the many subjects you are likely to encounter by the sea, and hopefully feel confident about going out to sketch. It is normal to feel a little apprehensive about working with strangers around, especially in crowded harbours in the summer season. If you sit on a stool painting, you will be fair game for the odd onlooker, **particularly if you set up an easel and have a large drawing board. You may find it less daunting to begin by taking along just one or two small sketchbooks and a few pencils and do a number of drawings while sitting or standing in less busy spots. People are likely to mistake you for a government snooper making notes – and thus keep well clear of you.**

A busy harbour is probably not the best place to start if you are apprehensive, though often you can find an outdoor table at a café from where you can sketch while you sip a cappuccino. People are generally reluctant to approach you while you are sitting in a café. If you get down into the mud of a harbour at low tide, however, the chances of being engaged are absolutely minimal. Boatyards, estuaries and quiet sections of beaches are where you are more likely to be left in peace, especially when the weather is less than glorious.

The rough sketch of Bunacurry harbour (see right) was carried out in a few minutes and is the sort of approach you may like to take initially. It is far from one of my best but is extremely effective in providing me with a strong composition from which to work up a painting. I have included it here just to show how you don't really need to spend ages working on complicated and highly-detailed scenes.

The *Sea Fret* sketch was made on a pleasant day with thick coastal mist, and with hardly anyone around – ideal conditions for achieving a moody composition. I used a water-soluble pencil and a water brush, a combination which can extend your possibilities and help you create an atmospheric effect in a simple pencil sketch.

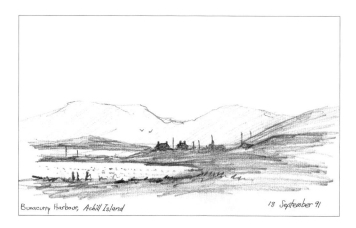

Bunacurry Harbour, Achill Island 18 September 91

Bunacurry Harbour

I include this roughly-drawn sketch to show not just how simple and quickly rendered it is, but to try to assure you that it is not vital to draw a complicated and perfect response to a scene. Some of my best paintings have resulted from ridiculous and almost indefinite marks on the paper, sometimes accompanied by a bit of mud. However brief and rough the sketch, you will always be learning from the experience, so go ahead and enjoy your sketching without being too critical of the results.

Sea Fret

The sketch was done with a water-soluble graphite pencil, an extremely effective way of suggesting mist quickly with a pencil.

Critical observation methods

Because we do much in life which is routine, our subconscious takes over and our brain does not have to consciously analyse every decision we make: changing gears while driving, for example. Similarly, when we are out sketching familiar objects, we tend not to analyse what we are looking at, and therefore fall short of making an accurate recording. We need to get into the habit of critical observation, where you carefully study and analyse the scene before you make any marks on the paper. Here are some starting points and tips.

- **Focal point** Determine what is the most interesting and exciting feature in the scene and position it just off-centre on your paper, with ample room around it for extending the surrounding features.

- **Initial line** Pick out a pronounced line on your selected feature: perhaps the roof-line of a building, the base-line of a boat (i.e. the waterline if afloat or the keel if lying in the harbour), or perhaps the horizon line. Start drawing this lightly in pencil. You will probably find that the line may be at an angle and not perfectly horizontal, so hold your pencil at arm's length and close one eye, keeping one end of the pencil appearing to be level with one end of your selected line. This rough guide is not perfect, but will help you gain an idea of how much the line slopes, and therefore ease your perspective concerns. Once your initial line is established, you can draw in adjacent detail such as the chimneys, ends of walls, doors, windows, and so on. Move outwards to include other buildings, vegetation and whatever is around or in front of your subject.

- **Artistic licence** Linear perspective can become complicated in ports and harbours, and you will find that in some places ancient buildings simply do not conform to normal perspective rules and their outlines can appear odd in this respect. I normally exaggerate any deformed perspective as it usually adds character to the subject.

- **Comparisons** Compare everything before you, not just in size or height, but the tones, how reflected light is affecting the various adjacent features, and where you see counterchange (where an object appears light where it is set against a dark background and appears darker higher up where it is set against a bright sky). Carefully study the colours before you – can you see subtle colours, such as reflected colours, appearing in part of the scene that were not obvious at first?

Noting these can enhance your finished work. Many of these observation methods can be done without your sketchbook, while you are simply waiting around, and it is helpful to train yourself in this way at every opportunity.

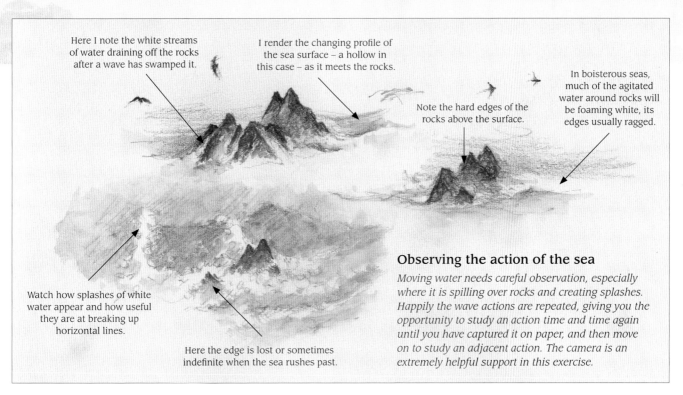

Here I note the white streams of water draining off the rocks after a wave has swamped it.

I render the changing profile of the sea surface – a hollow in this case – as it meets the rocks.

Note the hard edges of the rocks above the surface.

In boisterous seas, much of the agitated water around rocks will be foaming white, its edges usually ragged.

Watch how splashes of white water appear and how useful they are at breaking up horizontal lines.

Here the edge is lost or sometimes indefinite when the sea rushes past.

Observing the action of the sea

Moving water needs careful observation, especially where it is spilling over rocks and creating splashes. Happily the wave actions are repeated, giving you the opportunity to study an action time and time again until you have captured it on paper, and then move on to study an adjacent action. The camera is an extremely helpful support in this exercise.

Sketching methods

Having discussed how observation is critical to our response to a subject, and how it gives us a framework on how to render the more complicated aspects, here we look at how to tackle the overall composition. Where do we start?

The best way, when looking at a scene for the first time, is to determine which feature interests you most and begin the sketch with that centre of interest. Start the drawing with a strong base line or prominent line on the feature, and work from there. Study the overall composition for a few moments to ensure you can fit it all onto your paper, then start drawing lightly. Consider which features will support your focal point, what may act as a lead-in towards this feature, and which parts of the scene you should emphasize, and which to play down. Keep things simple to start. You don't have to put every window in a building or every boat in a harbour, and you can happily substitute that ugly blasted oak in the middle with the more handsome specimen you can see off-picture to the left.

Sketching in watercolour is a step further, of course, but a very rewarding one, because it also is a major step in improving your general watercolour painting. People tend not to be so tight while sketching in the medium as they are indoors when confronted with a large sheet of watercolour paper. I regularly work on good-quality cartridge paper for fast watercolour sketches, as the smooth paper helps to dry them quickly, but it takes time to learn to control washes on smooth paper. If you work with a wall or boat behind you, it may help you feel more secure, as painting with watercolours tends to attract more interest than just pencil work in a small sketchbook. Work quickly and don't worry about mistakes. Make notes in pencil or ink on the sketch and treat it like a working document. This approach can liberate you from feeling you have to create a perfect composition.

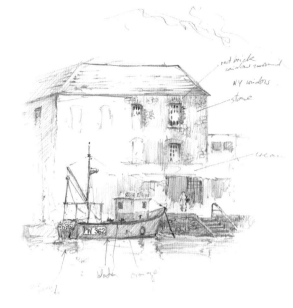

Mevagissey Harbour

Sketching in a harbour full of complicated boat and architectural shapes is a challenge, but you can simplify things by leaving out unnecessary detail. Here the fishing boat is the focal point and it has been rendered in detail, but directly behind it the building structure has been played down, even though I could see many features. To include them would cause visual confusion where they would meet the boat superstructure, masts and rigging, as well as over-work the composition. I briefly outlined some of the windows, while drawing one or two in detail. If they are all the same, it is not necessary to sketch all of them, and anyway I am unlikely to include them all in a painting. The stonework has been rendered only here and there – it's more effective to let the eye of the viewer put in the rest of the details. Note that I write in the colours if I am working in monochrome and need this information.

Sunlit Headland

A fair wind was blowing as I sat with my back to a rock, so the light kept changing. I enjoy these days because I can pick my moment when the light is in the optimum position. Watch the scene for a while before sketching and work quickly once you have decided on the lighting as it catches your centre of interest, which in this case is the far headland. I could have left out the right-hand half of the sketch and this would have made an excellent composition, but the whole scene was so lovely that I couldn't resist including the lot. Sometimes in cases like this where the distant headland is light, you may need to strengthen the tonal value of the adjacent sky area.

48

Painting in low light

Working at night-time or in low light is perfectly possible in harbour areas especially, and has the advantage that much detail is lost and the scene already incorporates a sense of mood. Colours are more subdued, and you may well find this easier to work effectively. I carry a head-torch with me, which means my hands are free to work. There are usually fewer people around to pester you. Tinted paper is an effective tool in creating these scenes and those produced by the Two Rivers company are particularly good for nocturnes as they are fairly dark tints.

Don't try to include every highlight – concentrate on two or three at the most, with one as the main focal point. You may need to slightly exaggerate the colours at this point. Naples yellow is excellent for light patches, especially on tinted papers, as it is opaque and works well with touches of white gouache, which are vital to bring out the highlights on non-white papers.

Evening at Walberswick
Low light left a potent mood over the place, almost ghostly with hardly anyone around as I worked quickly before the light faded. Note that while the light comes from the left, the blue boat in the foreground has its shadow on the left-hand side, because of the shadow of the bank. Details on the buildings were barely discernible.

Twilight at Tenby
Twilight can be a fascinating time to sketch as it automatically reduces the amount of detail before you and almost forces you to create a moody scene.

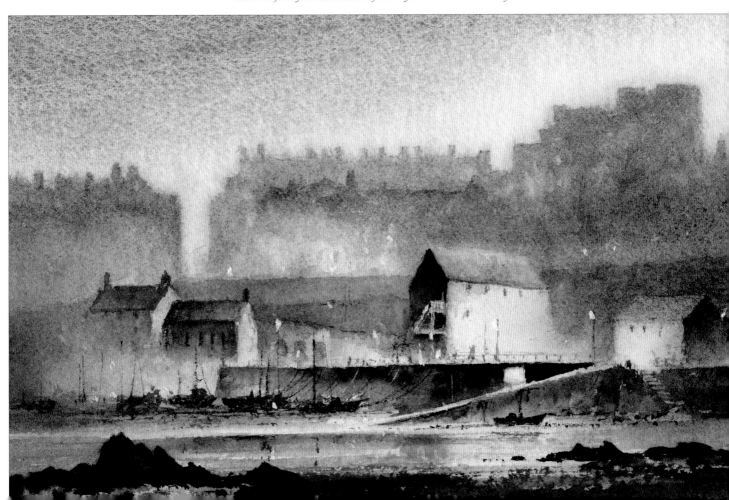

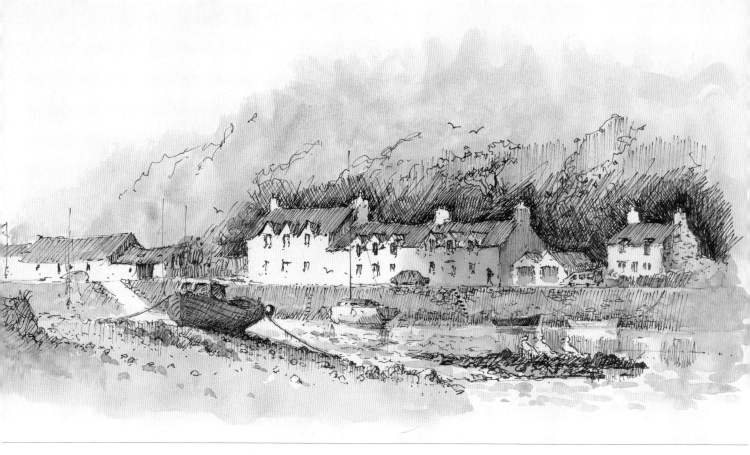

Pen and wash sketching

Modern pens come in a variety of types, line sizes and colours, and whilst it is hard to beat the style and varied line quality of the traditional dip pens, new developments are creating interesting possibilities. If you wish to work outdoors, of course, the bugbear of having to carry a bottle of ink around with you has always been inhibiting, so it is worth keeping an eye out for other pen types. In addition to the normal type of pen you may find brush-pens invaluable, especially as these can happily work on Rough paper – most metal tip or fibre-tip pens work best on smooth paper, such as Hot-pressed watercolour paper or cartridge paper. I enjoy drawing with a wide range of pens and these pages show a few examples of working you may like to try.

You can approach pen and wash work in a number of ways. If you are not so confident about your drawing skills, carry out an outline drawing lightly in pencil first, then ink it in. You then have a choice of either leaving it like that and continuing to the painting stage – which is how I have tackled the Kildavnet Castle sketch (see opposite, top), or you can apply tonal areas with the pen by hatching or cross-hatching as you see in the Fishguard Harbour sketch above. If you opt for a hatching method, creating dark areas with the pen, then all you need to do at the painting stage is apply washes of watercolour, ignoring the need to create varied tones at that stage. However, if you simply carry out a line drawing in pen without hatching, then you will need to apply watercolour in the normal manner, including stronger tones with your washes.

Fishguard Harbour

Pen and wash is an excellent medium for drawing harbour scenes, and an effective way to rescue a watercolour that lacks direction. In this particular sketch I have hatched in the dark areas with repeated lines of the pen to create the tones, so the subsequent washes need only be light applications, with no need for dark tones of colour.

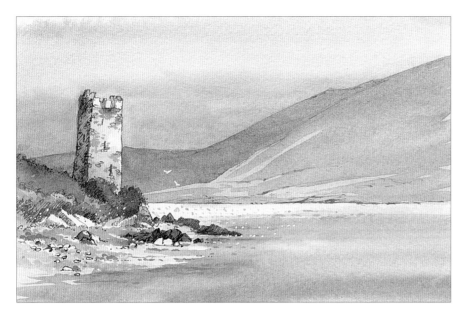

Kildavnet Castle

In the past, while working with pen and wash I used to render distant objects and clouds with a broken line, but now you have the option of drawing these with a grey pen and then using a black one for the foreground as I have done in this sketch. The grey pen I used was the excellent Derwent Graphik line maker. Derwent also offers a sepia pen in the same range. The washes were applied with indigo plus a touch of perylene red. Working in this way you can create a sense of depth in your composition more easily.

Although this was a perfectly fine day I deliberately laid on a misty background, partly because there was much repetition in the background cliff and partly to inject a strong sense of mood. By keeping the colours of watercolour washes and pen in harmony this adds to the mood of the scene

Delicious green slimy steps at the bottom, blending into even more mouthwatering muck at the top

Lonely Cove

This sketch was carried out initially with a sanguine pen, then a limited range of colours was painted on, restricting them to Naples yellow, yellow ochre, light red and burnt umber, with a slight touch of cobalt blue added to the burnt umber in places. In this way I achieved a harmonious result, resisting the temptation to render the deliciously slimy green steps and mouth-watering muck in their true colours. Unlike the Fishguard Harbour *sketch opposite, I have achieved most of the darker areas with stronger watercolour tones.*

Composition

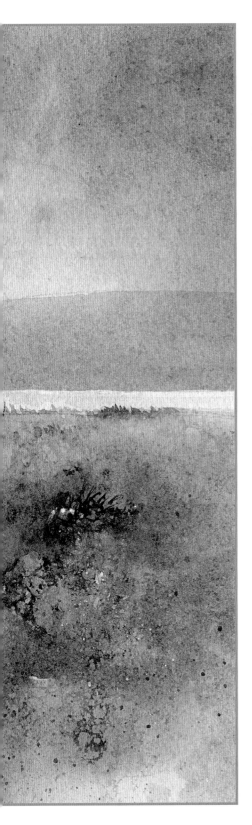

When you look around exhibitions and galleries these days you are confronted with a whole range of mind-boggling modern compositions in addition to the more traditional ones. One of the delights of working in the art world is to see the fascinating and individual ways in which artists have arranged their paintings on paper or canvas: some compositions appear to have a massive foreground and little else; others are cluttered with detail, perhaps without a clear focal point, or with just part of a focal point peering in at the edge of the work. You may well find all this confusing, but my intention here is to take a more traditional approach so that once you have absorbed the fundamental principles of composition you can then experiment to your heart's content with other more off-the-wall examples, if you so wish.

To help you achieve a sound composition from your sketch or photograph, do one or more small studio sketches in pencil, trying a slightly different layout of the scene each time, with a variety of positions for the focal point. This focal point is vital to success and is normally placed around one-third of the way into the painting, both vertically and horizontally, thus giving you four optimum positions. However, being precise in all this is not vital. Normally one focal point is best, but you will probably need subsidiary ones to enhance the balance of the overall layout. Think about creating a lead-in such as a path, river, wall, a rope linking a boat, or whatever seems appropriate, leading the viewer from the foreground into the general position of the centre of interest. Other features such as trees, bushes, fences, marine objects such as lobster pots or nets, colourful buoys, seabirds and people can all support the focal point if positioned close by, so don't hesitate to move these to your advantage.

Dylan's Boathouse
28 x 23cm (11 x 9in)

In this watercolour I decided to make more of the foreground with its lead-in of a small creek with a boat. The focal point is the building where I have given it the strongest tonal contrasts, and is positioned about one-third down the paper and almost one-third from the left side. The emphasis on the horizontals accentuates the haunting quality of the estuary.

Devices to give your paintings 'zip'

Painting a scene exactly as it appears before you is fine, but at some stage you will naturally feel you wish to put something of yourself into the painting. This is essential to produce a work of art rather than just a simple copy of what is in front of you, and the next few pages will illustrate how to stamp your own creativity and expression onto your painting. On these pages we will see how to create emphasis on cliff scenery in a subtle way, which can alter a view without really making the change so drastic that it no longer looks like the original scene. In addition we look at how to use the atmosphere to change a scene by obscuring features and emphasizing others. These devices will enable you to give your work more power without actually introducing any drastic changes to the scene.

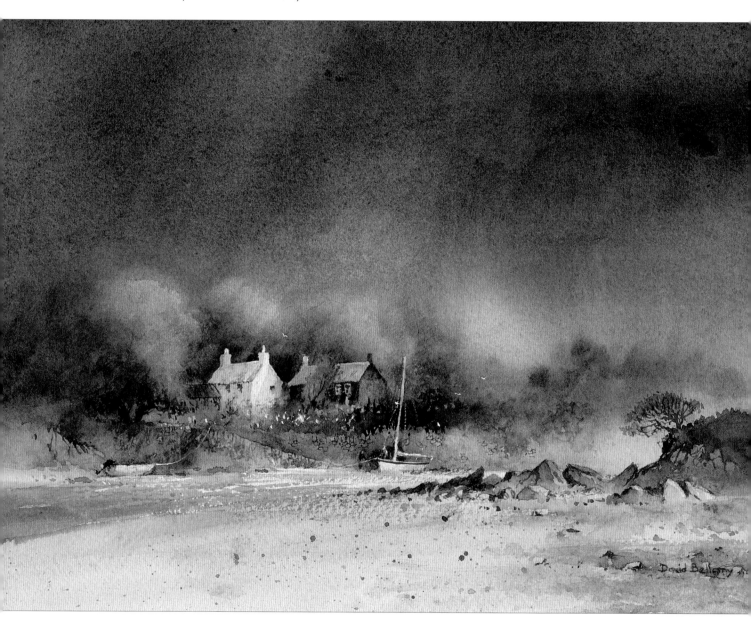

Moody Day, Sandy Haven
25.5 x 18cm (10 x 7in)

The atmosphere has been outrageously exaggerated, as it was a fine, sunny day when I visited the spot. I began by laying masking fluid over the buildings and boats, and then applied the main washes, working wet into wet with the various colours. Colour was pulled out of the upper part of the trees to suggest the lighter foliage. I enlivened the scene by applying a few dots of white gouache in front of the houses. Note that the actual scene has hardly been changed, only the atmosphere.

54

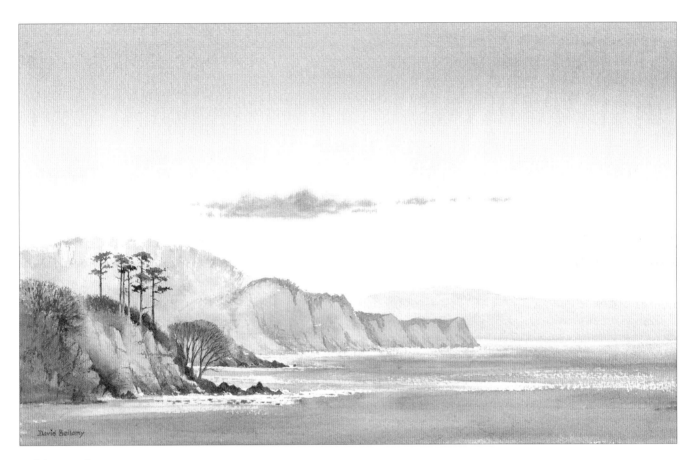

Babbacombe Bay
35.5 x 23cm (14 x 9in)

Although this is a beautiful subject, it did need a few subtle changes to enhance the effect. The line of cliffs was the same colour and tone all the way along, so my first alteration was to introduce some shadow on the further parts, and at the same time leave out much of the cliff vegetation which tended to intrude. With the centre of interest in the bottom left I suggested white foaming sea against dark rocks, and to make the trees stand out I deliberately lost all detail in the further tree mass to the rear, simply suggesting them with a wash of French ultramarine and cadmium red. Finally I reduced the strength of the contrasts at the extreme left cliffs by glazing over the area with a dark shadow. Strong contrasts at the edge of a composition tend to draw the eye out of the picture.

This close-up of the cliffs shows the area around the centre of interest.

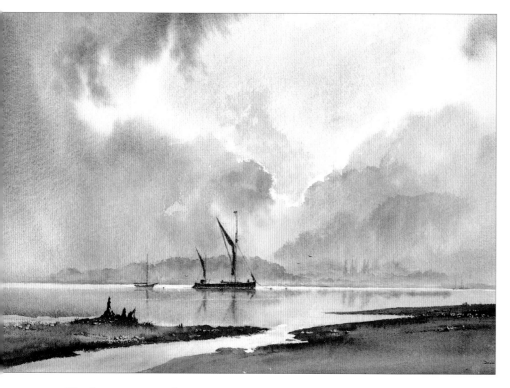

Blackwater Mooring
51 x 30.5cm (20 x 12in)

This was an overcast day with a cloudburst imminent, but I wanted to suggest a pleasant, sunny afternoon. I chose to paint this on Waterford Rough to help suggest ragged cloud edges and foreground textures. I started by lifting the sky from its dismal gloom with cobalt blue and a mixture of French ultramarine and cadmium red, splashing in strong new gamboge just above the prow of the vessel to liven it up. The Stygian background was replaced with a mass of trees using French ultramarine and cadmium red, with a touch of yellow ochre. Breaking up the foregrounds of horizontal shorelines with mooring posts, mini-creeks, weed-draped rocks and the like can add interest and avoid monotony.

Personalizing the scene

We shall now take this theme of improving a scene to our advantage a little further with a number of more pronounced changes, yet still keeping the scene reasonably faithful to the original. Locations are changing all the time, from the natural elements, sunlight, seasonal changes, new buildings, a new coat of paint on a door or wall, the arrival of a new boat, or simply a change in the state of the tide, which can drastically alter the water level and reveal or hide interesting features formerly visible or invisible. As a consequence, if we revisit a spot, we may find it looks quite different.

With the green rock tower illustration (see below) the simplification of detail around it was necessary to make the feature stand out – a vital compositional device – whereas the emphasis on the water splashes was a personal decision, as that was how I wished to add interest to the work. My changes in the *Blackwater Mooring* painting are mainly personal reflections on how I wanted the scene to appear.

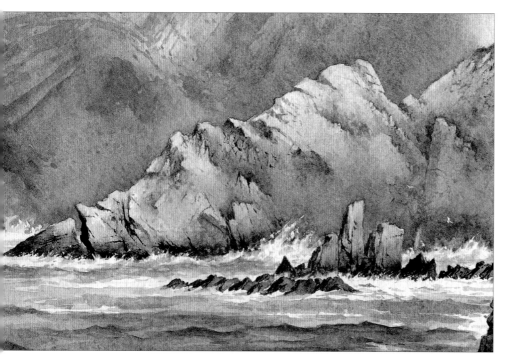

Detail from Rock Tower

This tower stands in front of complicated cliff architecture, and so to highlight it I left the cliff directly behind it devoid of detail – compare that part with the rest of the cliff. Further emphasis was achieved by juxtaposing dark rocks at the bottom of the tower against white splashes of surf. Adding in the splashes was a personal choice, as the sea was not nearly so boisterous.

Emphasizing the centre of interest

The most powerful way of making a centre of interest stand out is to highlight it with the strongest tonal contrasts available, which is the white of your paper set against your darkest tone. This does need care at times, though, when you have a more distant focal point and therefore need to suggest a sense of space in the painting, in which case your stronger tones might well need to be in the foreground. If there is little detail in the foreground dark areas while quite a bit of detail in the distant centre of interest, then this should work. Bright colours around or beside the focal point also help to indicate its importance, and I sometimes flood the rest of the composition with a dull glaze, keeping this away from the focal point so that, like a theatre spotlight, it shows up that feature to great advantage.

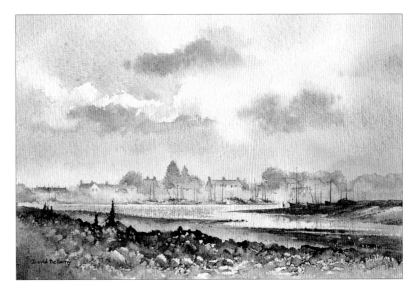

Burnham Overy Staithe
28 x 20cm (11 x 8in)

Here the focal point is a clutch of dark boats on the distant right. I highlighted them by keeping the far buildings faint, yet allowed their red roofs to show through and thus draw the eye towards the boats. These were rendered dark and sharp-edged, and while still wet I dropped a little red into some of them.

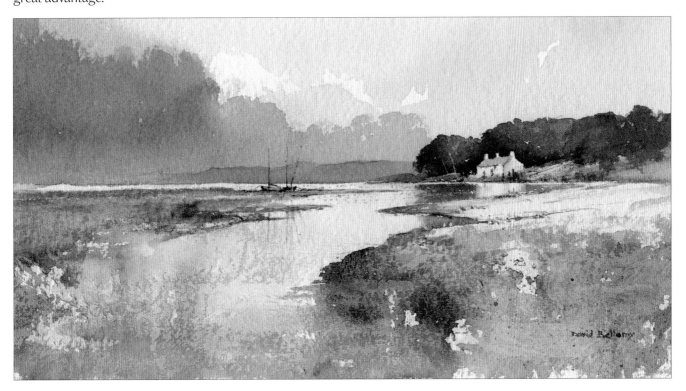

Nevern Estuary
23 x 11.5cm (9 x 4½in) 640gsm (300lb) Rough paper

Note that in this small composition the centre of interest has been highlighted in several ways: the lead-in of the River Nevern, the white building set against dark trees, the red boat moored outside and a few gulls circling nearby. The more central boats provide both a balance to the composition and break up the horizontal lines. The foreground was created by laying on a thin smear of Daniel Smith watercolour ground with a painting knife and leaving it overnight to dry before starting to paint. The work was done on an off-cut of Waterford 640gsm (300lb) Rough paper, as I like to use a stiffer paper when applying the watercolour ground.

Creating a sense of space and depth

The illusion of space and depth in a landscape or seascape is critical, even in an area of limited distance, such as a harbour or small rocky cove. Sometimes you need to considerably exaggerate the aerial perspective so that there appears to be much greater space between even groups of people sitting at tables on the quayside. With the *Teign Estuary* composition below, the feeling of depth is obvious, created by using cool colours for the distant hills of Dartmoor, and stronger detail and tonal values for the closer features. Warm colours will also make a passage seem closer to the viewer. The effect of stronger tones in suggesting space is more strikingly seen in the Black Point sketch (see right) as the headlands recede into the distance. When you are out on the coast you can get a better idea of this phenomenon by half-closing your eyes as you look at the scene.

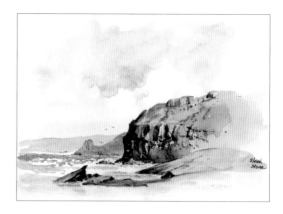

Black Point

In this small watercolour sketch the sense of distance, or aerial perspective, is suggested by making the far ridge of land light grey, then applying a warmer, stronger grey of cobalt blue and cadmium red for the intermediate headland. Finally a strong dark was painted for the closer cliffs.

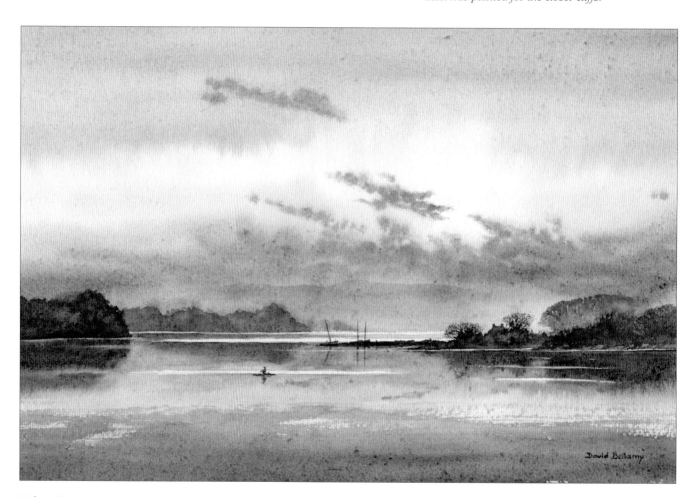

Teign Estuary
40.5 x 25.5cm (16 x 10in)

Beautiful December evening light pervaded this tranquil scene, compelling me to record it quickly while there remained sufficient light. The sense of space is accentuated by laying cool blue-greys for the distant hills and strong darks into the closer features, in particular the building, where I have also dropped in some cadmium orange to draw the eye of the viewer.

Working from photographs

When working directly from photographs it is even more important to start with a small studio sketch, especially if several photographs taken from slightly different angles are involved.

Avoid slavishly following the photograph and carefully consider the lighting, scale, positioning of main features, background, foreground and so forth. Consider the lighting in terms of direction, intensity and colour temperature, and where the main shadows will appear. Could the work be improved by changing the light direction?

Colours can be problematic if you insist on following exactly what is in the photographs, with overwhelming greens potentially being a nightmare. If all the boats happen to be white, it makes sense to depict one or two in strong colours − phthalo blue is an excellent bright boaty colour. An alternative is to add a red or blue line along the hull of a white boat.

A notorious problem when painting boats from photographs is that of trying to fathom out which bits of equipment or masts belong to which boat, or indeed what conceivable function they perform, and this is where doing sketches on the spot can help. If it looks odd, feel free to leave it out.

Photograph

I did not carry out an on-the-spot sketch in this instance, but the composition is a pleasing one and a fine example of how to work from a photograph, and at the same time strengthen the composition.

Studio sketch

As I intended to change the composition in a number of ways I drew a studio sketch to work out how best to tackle the painting. Firstly the shoreline bothered me – it cut across the composition too sharply, so I decided to introduce a dark rock promontory on the left. The background hills would be made cooler and more distant, and the buildings brought closer together. These compositional changes would give the work more power. I then turned to more personal considerations: the right-hand cottage would have chimney-pots added, a figure would be introduced, together with a lighter, summery feel, and the boat turned up the right way.

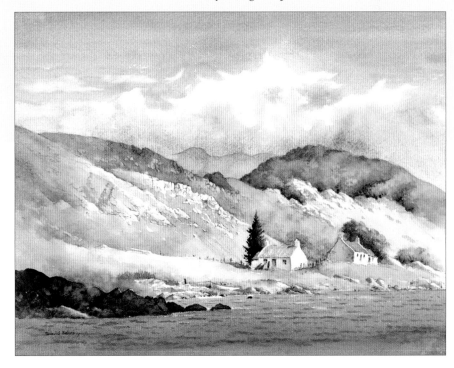

Cottages on Skye
30.5 x 23cm (12 x 9in)

The finished painting exudes a feeling of sunlight, due mainly to the shadow sides of the cottages and the light-coloured slopes, painted on a Not surface. In tackling a subject where the only source is a photograph it does pay to give careful thought to how you can improve even a good composition, and not copy everything slavishly.

CRAIL HARBOUR

The lovely old harbour at Crail has much to offer the artist, but whichever way you look the view is rather complicated. My aim here was to create a sunny aspect, with the background buildings reduced in detail with a hazy approach. The lower buildings, with their crow-stepped gables (where steps run up alongside the ends of the roof), make for attractive features and I emphasize these as the focal point.

Materials used

Saunders Waterford 640gsm (300lb) Rough watercolour paper

Brushes: Synthetic no. 10 mixing brush; large squirrel mop brush; no. 8 round brush; no. 3 round brush; no. 10 round brush; no. 6 round brush; no. 1 rigger brush; 6mm (¼in) flat synthetic brush; no. 1 round brush

Colours: Nickel titanate yellow; quinacridone gold; sodalite genuine; French ultramarine; yellow ochre; transparent red oxide; permanent orange; burnt umber; green apatite genuine; cadmium red medium hue; moonglow; light red; phthalocyanine blue

4B pencil

Masking fluid and old rigger brush

White gouache

Scalpel

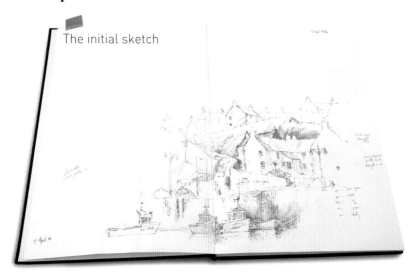

The initial sketch

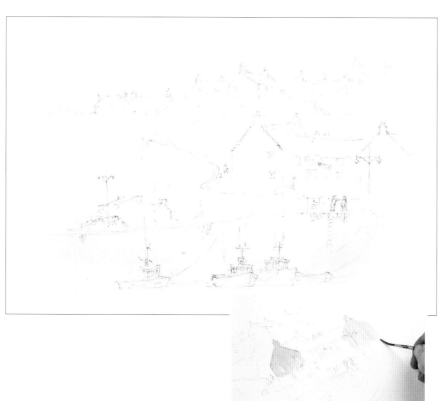

1 Referring to your photographs and initial sketch, use a 4B pencil to draw out the scene. In terms of composition, I want to subdue the distant background and the large area of brickwork, while bringing the group of buildings on the right into focus. I also want to introduce some figures to avoid the picture looking ghostly. You'll notice I have brought the lobster pots on the left-hand side more into the picture, in front of the left-hand building. I add the figures at the end, once the rest of the composition is in place, as they will always draw the eye to the focal point. When you come to the crow steps (see above), describe a faint line to guide you, then draw in the steps. Apply the masking fluid in the areas shown, using the old rigger brush (see inset).

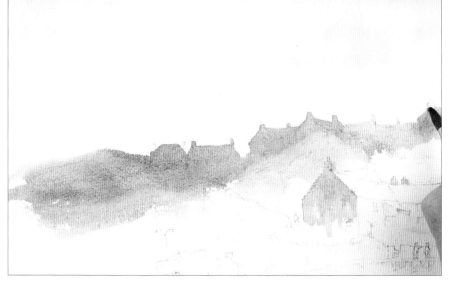

2 Use the large squirrel mop with clean water to wet the sky. Add in some nickel titanate yellow near the horizon, then add quinacridone gold to vary the sky. While the sky dries, prepare a dark blue-grey mix of sodalite genuine and French ultramarine. Once the sky is completely dry, paint along the ridge line. Working from left to right, use the side of the no. 8 brush to apply the blue-grey mix across the left-hand side. Change to the point of the brush for the buildings.

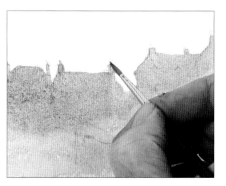

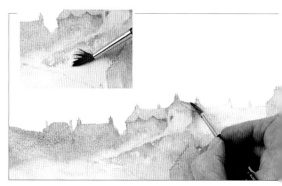

3 Working quickly, change to the no. 3 round and touch in the chimney pots while the paint remains wet. Add some quinacridone gold and yellow ochre wet into wet underneath the blue-grey area, working right the way across the painting. Use quinacridone gold particularly around the central figure on the steps – this will help draw the eye later.

4 Using the same blue-grey mix, develop a few areas on the closer background houses with the no. 6 brush. Avoid over-detailing the area, but add some visual interest. Use a lot of water on the brush to reduce the strength of the wash. Drop in a little yellow ochre on the right-hand background buildings for warmth.

5 Add dilute yellow ochre, using the side of the brush to create a slightly ragged edge behind the main buildings (see inset). This will create faint textural appearance to the area. Slightly warm the central area with dilute transparent red oxide, dropping it into the wet yellow ochre. If necessary, add further tonal touches, and refine the edges of the distant buildings once the paint has dried.

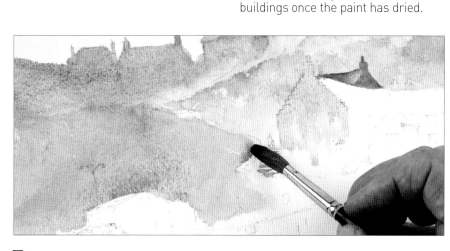

6 Still using the blue-grey mix of French ultramarine and sodalite genuine, begin to build up the houses in the midground with the no. 6 round brush. Drop in some transparent red oxide for warmth. Add the shadows of the central steps in the same way.

7 Change to the no. 10 round brush and add a variegated wash over the rocks on the left-hand side with the blue-grey mix and transparent red oxide. Leave some clean paper at the top of the wall, and emphasize the contrast by adding a little more blue-grey besides it. This gives the impression that the top of the wall is catching the sunlight.

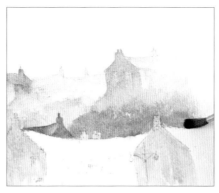

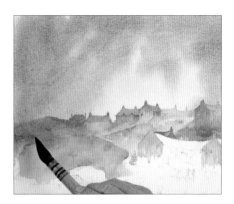

8 With a spare piece of paper to protect the top part of the building, use a damp sponge to lift out some of the blue-grey paint on the left-hand side to bring in a little more light here.

9 Develop the area behind the main buildings, softening the dark area (if necessary) by lifting it with a damp brush; and darkening the area behind the chimneys with a dark mix made by combining a little of the blue-grey mix (French ultramarine and sodalite genuine) with transparent red oxide.

10 Make a deeper grey by adding just a touch of French ultramarine to sodalite genuine. Rewet the sky with clean water using the large squirrel mop, then add the deeper grey mix wet into wet. Leave a central area of light. Tip the paper up slightly to encourage the wash to drift downwards. Use the no. 10 round brush to prevent any lines forming, by breaking any pooling and drawing away excess wash.

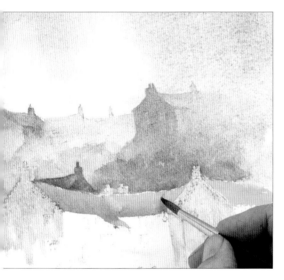

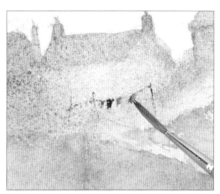

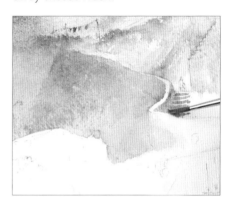

11 Lay the painting flat again. Using the no. 6 brush, paint the rooftop of the main buildings with permanent orange. Add transparent red oxide wet into wet for shadow near the bottom.

12 Once the painting has dried completely, use the no. 1 rigger with a mix of burnt umber and French ultramarine to add a clothesline above the red rock area. Add some clothes on the line using simple shapes, and bright colours to help them stand out.

13 Using the no. 3 round brush, add tiny touches of the drab mixes on your palette on the foreground area of the red rocks and near the figure. Develop the wall with the same dull mixes, adding shadow, then drop in a hint of sunlight on the top with yellow ochre.

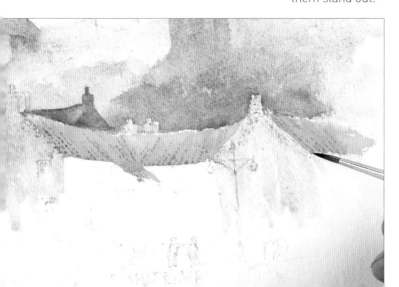

14 Still using the no. 3 brush, suggest the roof tiles with a mix of transparent red oxide and burnt umber. Work with the slope of the roof, adding parallel broken lines of colour. If any marks are too hard and obvious, touch them lightly with a finger to soften the effect. Allow to dry completely.

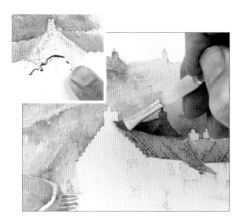

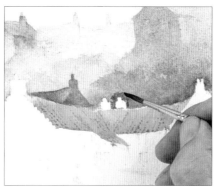

15 Use a clean finger to gently rub away the masking fluid (see inset), then dampen with the 6mm (¼in) flat synthetic brush, and gently agitate the crisp edges left by the masking fluid, softening them subtly into the painting.

16 Change to the no. 1 rigger and tidy any loose edges on the rooftop with the blue-grey mix of sodalite genuine and French ultramarine. Soften the colour into the surroundings to avoid a hard line on the background.

17 The light is coming in from left to right, so I want to add a subtle shadow to the roofs in the shade. Use the blue-grey mix, fairly dilute, to add the shadows. On the right-hand side, near the edge of the painting, use a slightly stronger mix. This will ensure that the colour is not too strident, which would lead the eye out of the painting.

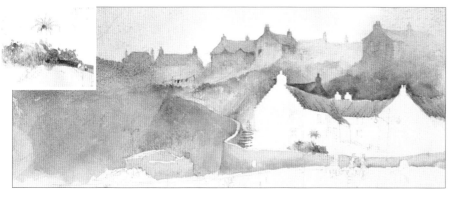

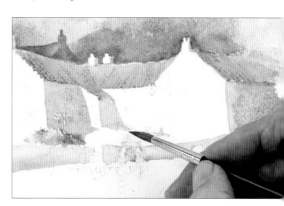

18 Using the no. 1 round brush, paint the palm tree and greenery in front of the main building with green apatite genuine (see inset), then add dilute blue-grey mix behind the lobster pots on the left-hand side. Drop in touches of dilute yellow ochre and phthalocyanine blue to push some light into the area. Still leaving a white rim where the top of the wall is catching the sunlight, do the same on the central foreground area. Add some transparent red oxide wet into wet near the base of the wall.

19 Add shadow to the foreground buildings using the no. 6 brush and French ultramarine. Use the tip of the brush to work carefully around and into the details.

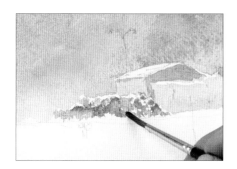

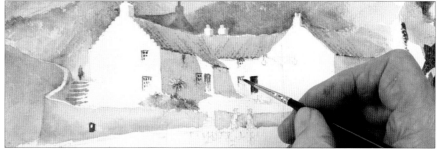

20 Use the no. 3 round to develop the lobster pots with the blue-grey mix (sodalite genuine and French ultramarine), and transparent red oxide. Add some striking impact with touches of cerulean blue.

21 Use the no. 1 round to paint the lifebuoy and front door with cadmium red medium hue; and sunlight on the chimney pots with nickel titanate yellow. Paint the central figure, using the same yellow for her hair, transparent red oxide for her coat, and moonglow for her legs. Work carefully, allowing the colours to mix a little wet into wet, but not so much as to become indistinguishable. Use a deep mix of French ultramarine and burnt umber to paint in the window panes on the main building. Add some shadow under the eaves, too.

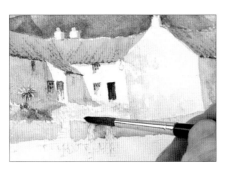 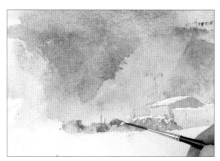 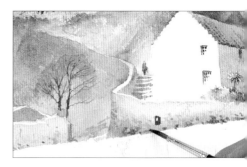

22 Still using the no. 1 round brush, add tiny touches of French ultramarine to suggest the positions of the corners of the walls. Change to the no. 6 round brush and use dilute touches of blue-grey (French ultramarine and sodalite genuine) and yellow ochre to create a mottled effect on the wall and courtyard area.

23 Develop the rocks on the left-hand side, adding colour to the dark area around and behind them. Use the blue-grey mix of French ultramarine and sodalite genuine, and the no. 6 brush. Change to the no. 1 rigger and use the same mix to add some detritus near to the lobster pots, hinting at a few posts and similar shapes.

24 Still using the rigger and the blue-grey mix, add the trunk and main branches of a tree. Dilute the mix and use the side of the no. 3 brush to add foliage. Work along the foreground wall, using the tip of the same brush to add blue-grey touches that suggest stonework. Vary the effect by adding light red into the wet paint.

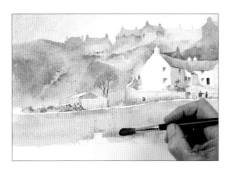 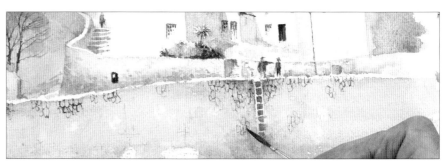

25 Paint the sea wall using a combination of yellow ochre and the blue-grey. Use the no. 10 brush with long horizontal strokes, working carefully around the boats. Add dilute light red wet into wet, followed by green apatite genuine. Use less water with the green.

26 Tighten up the green area by the focal buildings with the no. 1 round brush and a mix of French ultramarine and burnt umber. Develop and detail the street furniture (the lamppost, the life belt, rubbish bin and ladder) with the same colour. Using the rigger with burnt umber, paint the stonework. Vary the pressure you apply, and the amount of paint on the brush, to create variety. More pressure leads to stronger marks and wider lines; less pressure the opposite. Don't try to paint every brick – instead focus on critical areas. You want to evoke the overall effect, rather than take up building as a second job!

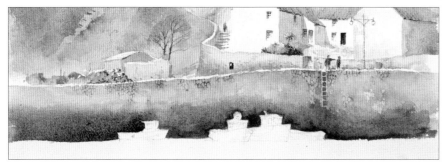 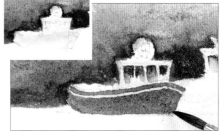

27 Change to the no. 6 round brush and glaze the sea wall with a dilute grey-green mix (apatite genuine mixed with French ultramarine and sodalite genuine). Add touches of transparent red oxide and yellow ochre wet into wet. Add some powerful darks to the base of the wall to help push the rest of the painting backwards. Use a dark mix of French ultramarine and burnt umber, applying it with the no. 6 brush and softening it in to avoid hard lines.

28 Paint the central boat with phthalocyanine blue (see inset), and the windows with the dark mix using the no. 3 round. Once the central boat is dry, overlay the dark mix (French ultramarine and sodalite genuine), leaving a fine line of the lighter blue showing through.

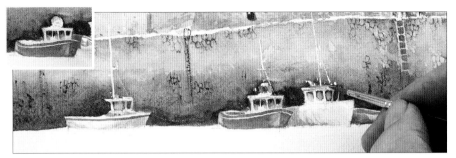

29 The boats are an opportunity to introduce bold, bright colours in the foreground. Lift out some paint with the 6mm (¼in) synthetic flat brush to help suggest the shape of the hull (see inset). In addition to the dark mix, add phthalocyanine blue, cadmium red medium hue, and permanent orange to bring in some bold marks; and French ultramarine to subdue the white while keeping the shadows vibrant. Use the no. 1 rigger to paint the masts and other uprights with white gouache.

30 Use the tip of a scalpel to scratch out some ropes from the boats to the harbour.

31 Wet the sea area and apply a mix of French ultramarine with a little burnt umber, using the no. 10 round brush. Leave gaps to serve as reflections beneath the white-hulled boats, and soften the edges with a damp brush. Add a little subtle phthalocyanine blue beneath the blue boat and soften in the same way.

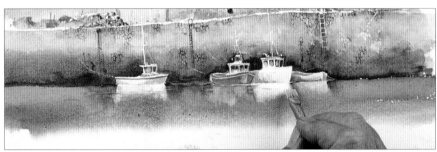

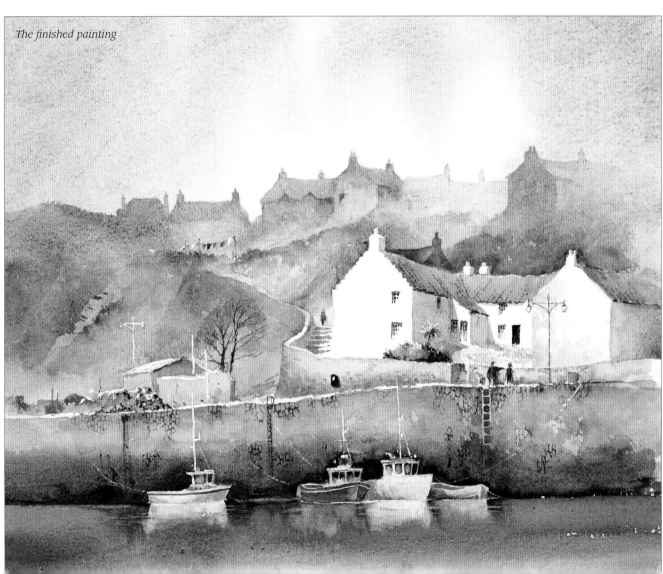

The finished painting

Figures and birds

Without doubt, introducing figures and some wildlife in the forms of seabirds into your coastal paintings will greatly enhance your work. Here we look at figures.

Take every opportunity to sketch people, particularly those working or taking part in some activity, perhaps working on a boat or mending nets as in the sketch of two figures at Hastings. It is even more effective if you have them relating to each other in some way, chasing each other through the surf or tending to children, for example, or perhaps hauling a boat out of the water together.

The sketches of *Turbulent Launching* began with rapid, gestural strokes of the pencil, the detail added at a more leisurely pace once the main action of the figure had been captured. Information such as wetsuits and life-vests can be drawn onto a separate page if necessary, but you should concentrate on the action: it is vital that you capture the dynamic poses the figures are in. Don't be daunted by the prospect as you soon become more adept at capturing such images. Build up a reservoir of sketched figures: some that are fairly close-up, as in *Beach at Collioure* (opposite, top); some in the distance, as with the massed bathers (below), which are little more than dots; and of course those figures in between.

Seek out working people to add to your collection and try to sketch them in different positions so that you have a reservoir of figure sketches from which you can choose to include in a painting.

By observing figures in action you can make them look more authentic. Here the outstretched arm suggests a heavy bucket being carried.

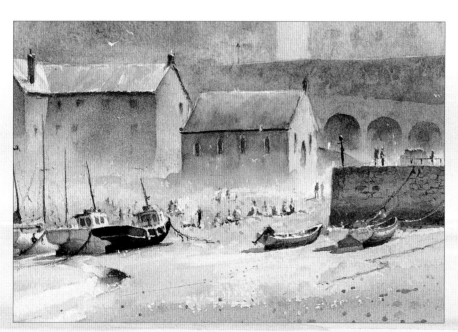

Rendering distant figures on a beach calls for careful placement and a simple approach to avoid over-working. Suggest them rather than work in detailed individual figures, and allow them to run into each other within a group.

Beach at Collioure
28 x 20.5cm (11 x 8in)

With close-up figures emphasize one or two together, or a group, rather than give all figures on the beach equal prominence. By putting more colour on the red-headed figure on the right it is that group which forms the focal point. By comparison the left-hand figure is less prominent. The sparkling water was achieved with a couple of horizontal lines of weak French ultramarine dots and when the blue wash had dried, I blobbed in a lot of dots with white gouache.

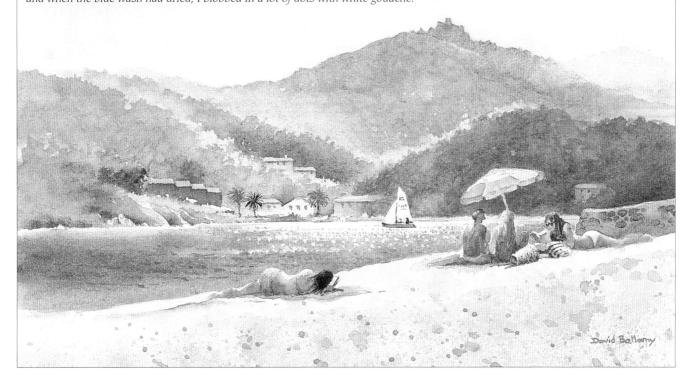

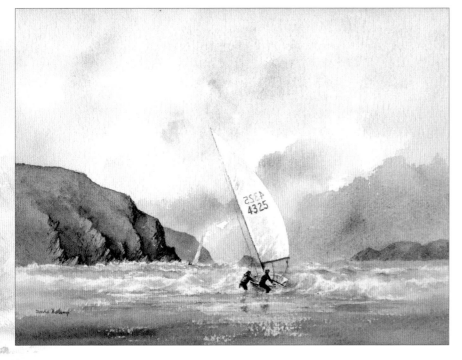

Turbulent Launching
30.5 x 20.5cm (12 x 8in)

Finding myself in the midst of a regatta being launched, I took the opportunity to carry out a number of sketches of people in action (see below), which I much prefer to folk just hanging around.

In the finished painting, the ragged effects on sea and sky suggest a windy day as the two figures battle to get their craft into the animated surf.

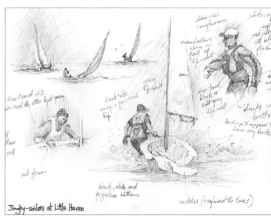

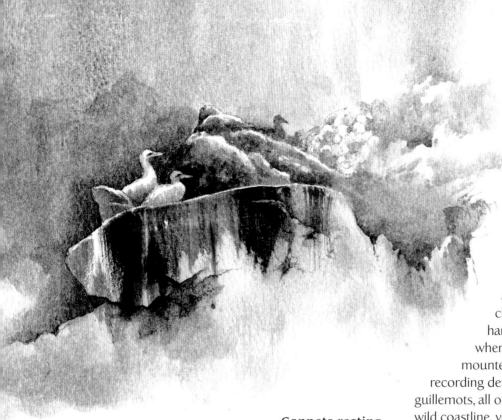

Seabirds

While it does suggest a sense of life in a coastal scene, adding in a few quick v-shaped marks in the sky may well leave some artists unsatisfied. You may wish to make more of the wildlife aspect, especially in natural locations such as cliffs, rocks, estuaries or surf-line.

Common seagulls are fairly easy as they are happy to pose for some time, allowing you the opportunity to sketch and photograph them on boats, rocks, chimney-pots and so on. Cormorants hang out on rocks close to the shore where you may find a pair of binoculars mounted on a tripod more effective for recording detail. For gannets, puffins, razorbills and guillemots, all of which make superb focal points on a wild coastline, you usually need to take a boat out to an island to find them, but once you are there it tends to open up all sorts of exciting possibilities for you. Puffins in particular seem far from timid and may come extremely close. Their antics often seem crazy and always endearing, and they are just about the easiest bird to paint and create a likeness. Guillemots and razorbills tend to stand statuesquely together on rocks and cliff ledges for ages, so again are easy to render. It helps to have optical assistance. Gannets are distinctive and when they are not hurtling through the air at speed, they can make superb subjects as they sit in groups.

Gannets resting
18 x 15cm (7 x 6in) 300gsm (140lb) Not paper

I originally sketched these gannets from a boat bobbing about under the dramatic black cliffs of Grassholm Island. As they were sitting still and are distinctive birds, they did not really present a great problem. With the large rock on which they sat I took a piece of watercolour paper about 5cm (2in) square and dipped one end of an edge into yellow ochre and the other end into indigo and then scraped it down vertically from the top of the rock, needing to do it three times to cover the whole rock. The technique worked well on the Not surface. Afterwards, with a fine, damp 12mm (½in) brush I tidied up the top of the rock where it catches the sunlight, and also pulled out a short horizontal highlight near the right-hand end to add interest.

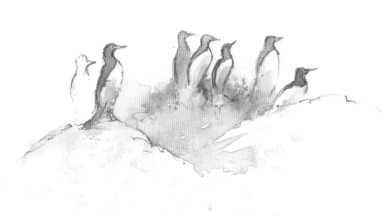

Guillemots

Guillemots love to stand around and chat on ledges and rocks, and while like this they are relatively easy to sketch, although you will probably need a pair of binoculars or a spotter scope to record any detail.

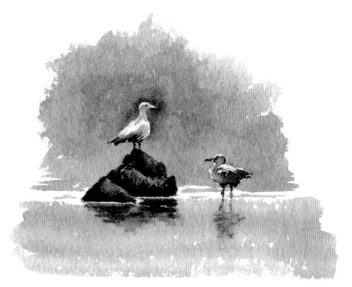

Gulls posing

Seagulls are great posers and happily stand for ages on the beach, on top of boats, chimneys and the like, and you can often get close to sketch, but keep your sandwiches out of sight!

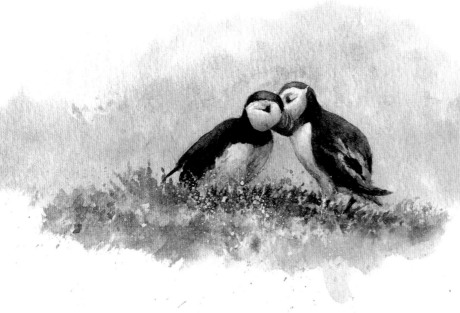

Puffin Secrets
18 x 10cm (7 x 4in)

Whenever I visit Skomer Island in late spring the puffins always leave me speechless with their antics as they almost run between your feet. If you love sketching bird behaviour, this is the place to be, and they are just about the easiest bird from which to attain a likeness.

Birds in flight

Generally the best place to view birds in flight are the tops of cliffs, and sometimes you will find them hovering against a strong wind, which is an ideal situation to sketch. Find those places where they regularly fly past so that you can draw the bird's features in stages – in reality using several different birds to create the one image, as it is almost impossible to capture all the detail in one pass.

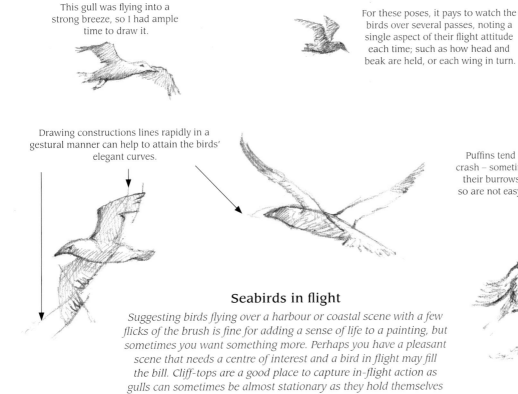

This gull was flying into a strong breeze, so I had ample time to draw it.

For these poses, it pays to watch the birds over several passes, noting a single aspect of their flight attitude each time; such as how head and beak are held, or each wing in turn.

Drawing constructions lines rapidly in a gestural manner can help to attain the birds' elegant curves.

Puffins tend to land with a violent crash – sometimes diving straight into their burrows to escape predators – so are not easy to draw in this action.

Seabirds in flight

Suggesting birds flying over a harbour or coastal scene with a few flicks of the brush is fine for adding a sense of life to a painting, but sometimes you want something more. Perhaps you have a pleasant scene that needs a centre of interest and a bird in flight may fill the bill. Cliff-tops are a good place to capture in-flight action as gulls can sometimes be almost stationary as they hold themselves against a strong breeze. In the lower two birds (centre and left) I have included construction lines to aid accuracy.

Including birds in a painting

Deciding on the scale of the birds – how large to make them relative to the scenery – can be tricky, but if they are to become the focal point, they do need to be reasonably large, though not necessarily filling a huge part of the composition.

In *Heavy Seas, Grassholm* the birds are of varying sizes, the ones furthest away being little more than vague detail that could be mistaken for a cloud or spray.

If you have perhaps ten thousand birds in a painting similar to this, you do need to make a small group of them stand out as a centre of interest, perhaps resting on a shapely rock.

Heavy Seas, Grassholm
38 x 25.5cm (15 x 10in)

Thousands of gannets nest on the island and the air is full of birds, so apart from a few rendered in a certain amount of detail, the majority have to be suggested as a mass. In places I have used white gouache for this purpose – alternatively, you could try masking fluid. In the distance I have deliberately made hardly any differentiation between the guano-covered rocks and the birds themselves.

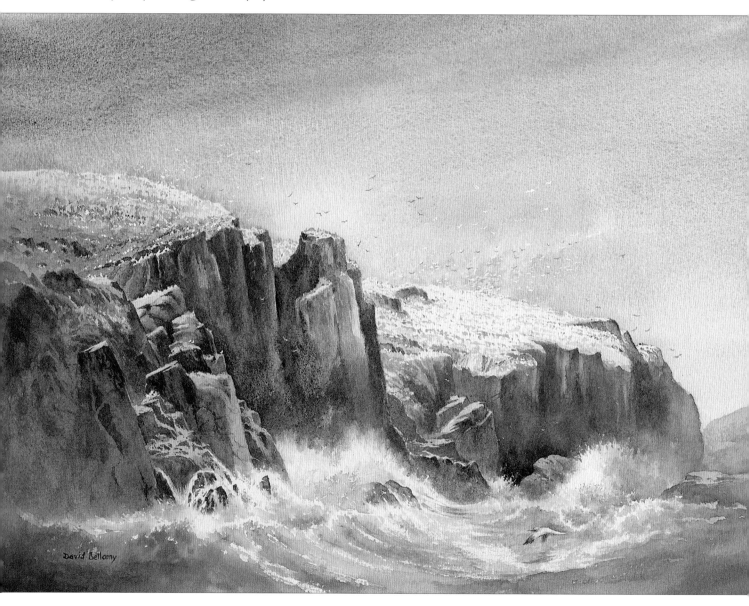

David Bellamy

Stage 1: With strong horizon lines and shadow bands across the water surface you may find low-tack masking tape a helpful device. Used boldly and without much by way of softening effects it can appear to be a strong stylistic change from your normal work, especially as its presence can make you bolder with your washes. Note that it would probably not work quite so well on a Rough surface because of the likelihood of seepage, so here I used a sheet of Waterford Not paper.

Evening Calm
45.5 x 28cm (18 x 11in)

In the finished work (below) I have slightly softened the edges of the shadow bands with a damp brush before working on the foreground details.

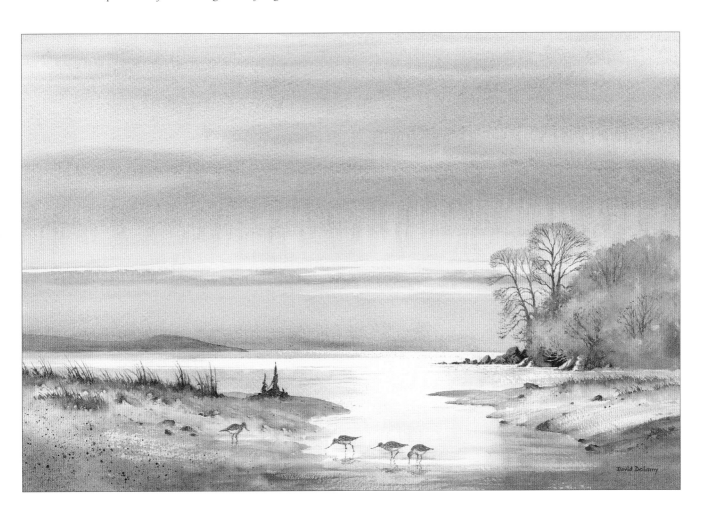

LONELY CORMORANT

This demonstration has a cormorant as the focal point; it is all about rocks and a boisterous sea set against a moody backdrop. When deciding on the subject, I chose one of many sketches of cormorants and a sketch of rocks in a different location, bringing it all together in a studio sketch before working on the final painting.

Many people have trouble painting rocks, so here I introduce an alternative approach in the form of collage using thin oriental papers, which contain quite prominent fibres, applied with PVA glue. When using this technique I prefer to paint on heavier papers of 425gsm (200lb) or 640gsm (300lb) weight.

Materials used

Saunders Waterford 425gsm (200lb) HP watercolour paper

Brushes: No. 14 round; no. 10 round; large squirrel mop; 12mm (½in) flat synthetic; no. 4 round; no. 1 rigger; old mixing brush

Colours: French ultramarine; cadmium red medium hue; nickel titanate yellow; lavender; burnt umber; phthalocyanine blue; quinacridone sienna

3B pencil and putty eraser

PVA glue and old brush

Scissors and oriental paper

Kitchen paper

Old toothbrush

White gouache

Scalpel

Oriental collage

Splashing waves

The initial studio sketch. While I was happy with the bird in the main drawing, I preferred the rock structure of the upper small sketch.

1 Using a 3B pencil, refer to your initial sketch while you draw out the scene.

72

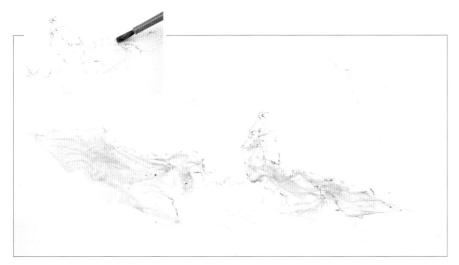

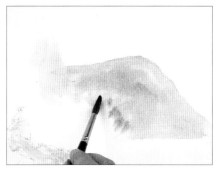

2 Working flat, water down a fair amount of PVA glue, mixing it up with an old brush. Use your scissors to cut some rough shapes from the oriental paper. Tear the pieces to roughly match the shapes of your foreground rocks, cover them with a layer of glue and then place them on the surface. Use your fingers or the brush to position them, aiming to create a rough textural surface (see inset). Work up to the pencil lines of your sketch, but not over – this would create a fuzzy edge, which would look odd on the hard edges of the rock. Build up the foreground rocks gradually – keep the pieces of oriental paper small; if you try to work too large an area at once, you will likely find the paper collapses on itself and becomes unworkable. Allow to dry thoroughly, preferably overnight.

3 Wet the splash area near the centre of the picture, to the right of the cormorant, using clean water and the no. 14 brush, then add a purple mix of French ultramarine and cadmium red medium hue with the no. 10 round brush. Add more of the purple mix wet into wet near the base, aiming to create a soft edge around the splash area.

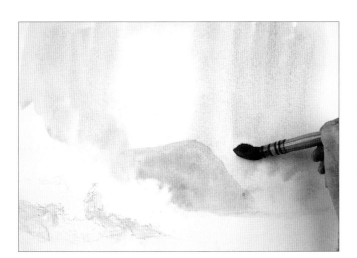

4 Once dry, wet both the whole sky and the rocky area you have painted using clean water and the large squirrel mop. Still using the squirrel mop brush, lay in nickel titanate yellow, leaving a small gap near the top. Pick up lavender on the squirrel mop and lay in vertical strokes to the right- and left-hand sides of the yellow area. Vertical strokes add to the drama. Use an old mixing brush to soften the lower edges of the wet paint, then allow to dry.

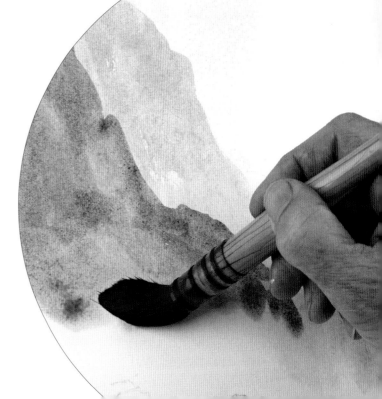

5 Change to the no. 10 round. Use a medium-strength grey mix of French ultramarine and burnt umber to paint in the edge of the distant cliff with the side of the brush. Soften the bottom away. To add an area of mist behind the cormorant, wet the base of the midground rocks with the large squirrel mop, then lay in a slightly stronger grey mix of French ultramarine and burnt umber down the left-hand side.

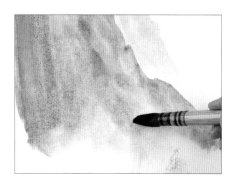

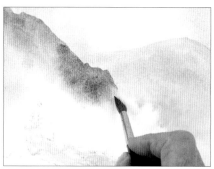

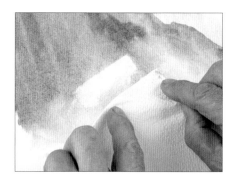

6 Work down into the wet area, then add phthalocyanine blue wet in wet.

7 Apply more of the stronger grey mix using the no. 10 brush to strengthen the rib of rock on the right-hand side, bringing it down into the mist, then softening it away.

8 Lay some kitchen paper down into the wet paint just above the misty area on the right-hand side, then lift it away to suggest a rocky shelf.

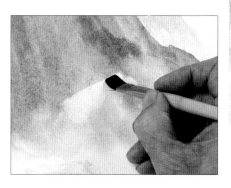

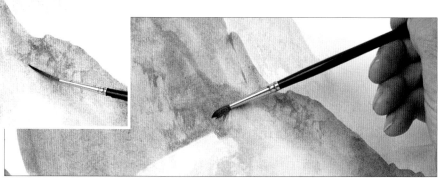

9 Use the damp 'blade' of the 12mm (½in) flat synthetic brush to refine and sharpen the top edge of the lifted-out rocky shelf.

10 Load the no. 1 rigger with the same stronger grey mix of French ultramarine and burnt umber to develop the midground rock face (see inset), creating fracture lines with the point, and general texture with the side of the bristles. Create more texture on the left-hand side using the no. 4 round brush in the same way. Work down to, but not over, the lifted-out area.

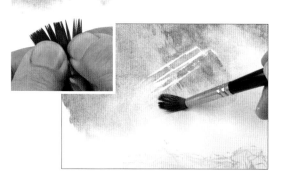

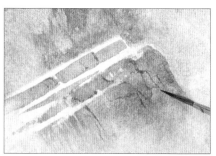

11 Use the 12mm (½in) flat synthetic brush to add short, broken parallel lines of the stronger grey mix of French ultramarine and burnt umber to the shelf of rock. Split the bristles (see inset) and use the brush to add textural colour and detail, adding in touches of yellow ochre, too.

12 Change to the no. 6 brush, and use the same mix of French ultramarine and burnt umber to strengthen the shadow on the right-hand side of the shelf. Once dry, add fracture lines to the shelf using the no. 1 rigger, again with the dark grey mix.

13 Wet the area to the left of the cormorant, and add some more of the stronger mix of French ultramarine and burnt umber, drawing it down into the wet area. This will give the impression that the rocky shelf is emerging from behind the foam.

 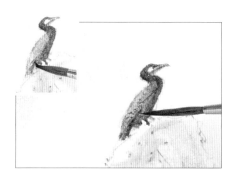

14 Wet the sea area with a damp sponge. Still using the same stronger grey mix, load a no. 6 round and begin to paint the hazy distant water, using wandering, horizontal touches of the side of the brush. Working wet into wet, add hints of nickel titanate yellow into the sea near the focal point (the cormorant). This will create eye-catching greens and prevents the sea looking dull.

15 Still using the no. 6 brush, wet the inner part of the splash with clean water, then add some subtle touches of the grey mix (French ultramarine and burnt umber). Add some more grey into the nearby sea, too, and work up to and over the textured rocks beneath the cormorant. Allow the area to dry completely.

16 Paint the cormorant with the dark grey mix and the no. 3 round. Use short controlled strokes, and leave gaps for markings and detail (see inset), then wet the brush and soften the colour into the light areas. Touch in some phthalocyanine blue for the sheen on the feathers. Allow to dry, then use the no. 1 rigger to add a few darker flecks to the back in order to suggest some feather texture.

17 To paint the pre-textured rocks beneath the cormorant, use a no. 10 round brush to apply a dark mix of French ultramarine and burnt umber. Use a strong but fairly fluid mix to help it reach the recesses. Add quinacridone sienna for warmth, and to bring the area forward.

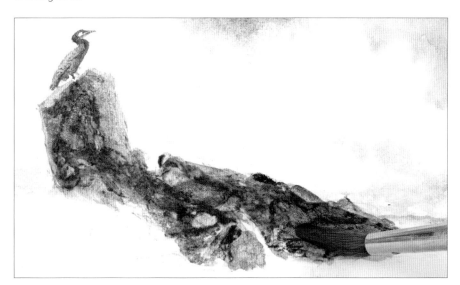

18 Paint the other foreground rocks with the same colours and techniques. Use French ultramarine to paint the shadowy midtones of the water draining from the rocks, applying the paint with the no. 3 round brush and using the strokes to indicate the direction of the water.

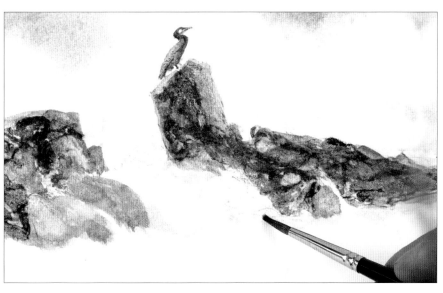

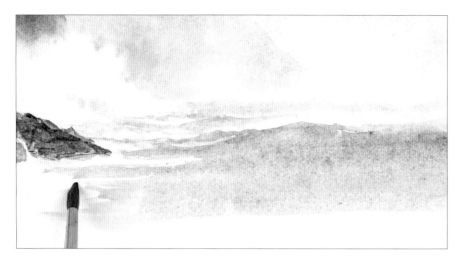

19 Extend the sea into the foreground by building a stronger-toned band of the water with the no. 10 round, using the grey mix (French ultramarine and burnt umber). Add a touch of nickel titanate yellow, and light marks using the grey mix, to add interest to the water.

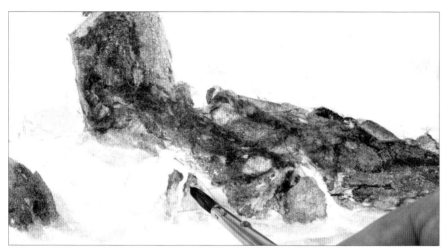

20 Using the tip of the brush, add faint broken marks of the pale grey mix into the pool of foam, strengthening them here and there for depth.

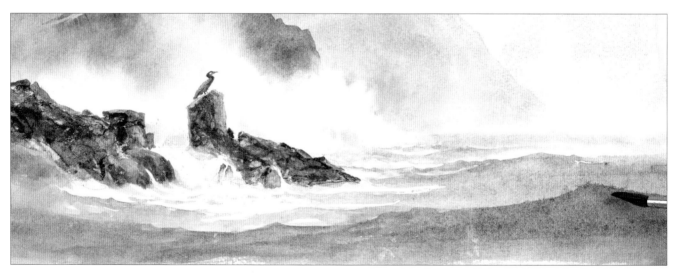

21 Change to the no. 4 brush and use the strong grey mix to add in rocks visible within the foam. Keep the tops of the marks hard and clear, and soften them nearer the base, where they disappear into the water. Use the same mix to refine and sharpen the foreground rocks, then change to the no. 10 round brush and paint the sea on the left-hand side with the paler grey mix. Take the water up to the rocks themselves, using broken horizontal strokes. Leave a few gaps of white paper visible, particularly nearer the central foam, and use darker mixes towards the edge of the paper. You can create a darker band of waves at the border of the picture, suggesting some wave peaks.

22 Allow to dry, then use an eraser to remove any intrusive pencil marks. Lay kitchen paper to help mask any important areas, then tap your old toothbrush into a pool of slightly diluted white gouache. Hold the toothbrush over the foam area, and gently draw your thumb over the bristles to spatter paint onto the surface.

23 Finally, use the point of a scalpel blade to carefully scratch out a few subtle highlights on the sea.

The finished painting

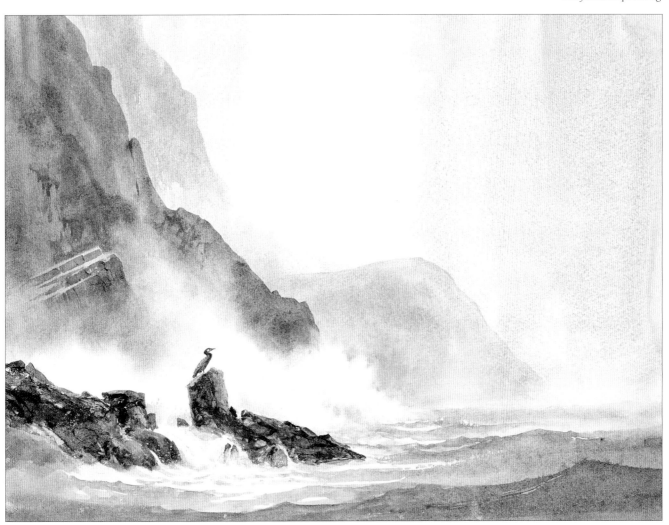

All at sea

Working from a boat is not for everyone, even just offshore on a fine summer's day, but it does give you an interesting new perspective on the coastline. You see things that you would not otherwise observe, whether on a ferry across the channel, a two-hour boat trip round the bay to watch the dolphins, a ten-day cruise, or major expedition to some far-flung coast.

Working from a boat

I've used all sorts of methods of exploring coastlines, including kayaks, rubber rings and simply treading water in a wetsuit with a water-resistant sketchbook, but there's no way I would call myself a sailor, even when I was being tossed around a small yacht in a wild Arctic storm like a pea in a boiling cauldron.

Wild Cove, Ramsey Island was sketched from a powerful boat on the exposed Atlantic side off Pembrokeshire. These short trips can give you some excellent material even when the boat heaves up and down, as in this case. Being well prepared is half the battle, with simple, uncomplicated materials to work with: a full watercolour set and easel would be difficult to control. Take a pad or two of paper with some graphite water-soluble pencils, watercolour pencils and a couple of water brushes. Always having spares on trips like this is sensible, as things can easily fall overboard or get lost. Take a plastic bag for your camera and don't get it out until you know which direction the spray will be coming from (it can still catch you and drench you in seawater), but it's less hazardous if you can find shelter in the lee of the cabin.

On a pleasant day in calm conditions, working with a simple watercolour kit can be effective. Watercolour pencils are an excellent medium for sketching at sea, especially as they are easier to control on a rocking boat. You will probably need to work quickly if you are close to the shore as the perspective changes rapidly. Even if the boat is not under way, it will be moving around with the movement of the sea, so capture the essential features at speed if you can.

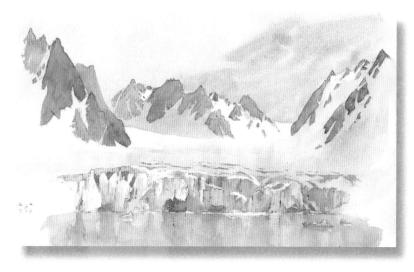

Sellstrombreen Glacier, Svalbard

Our small boat was heading directly for the glacier, which at this point was miles away, so there was plenty of time for me to work up the sketch. As in this case, I often apply pencil hatching to the darker areas, intending either to apply watercolour later, or once the drawing stage is complete. Note the varied colours in the glacier face.

78

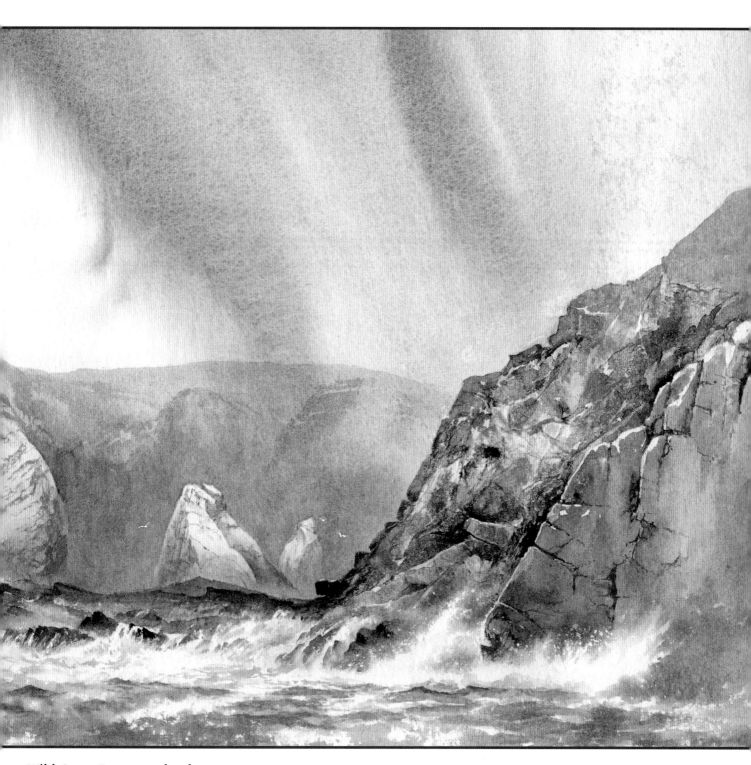

Wild Cove, Ramsey Island

43 x 30.5cm (17 x 12in)

This shoreline of the island is exposed to Atlantic moods which on this day were throwing the craft around, and so not the easiest time for sketching. On the plus side, it does mean that dramatic splashes of water and waves make the composition much more interesting.

Tackling the coastline from the sea

Sketching and painting from a little off-shore provides the artist with a totally different perspective of the coastline. It usually allows you to manoeuvre into interesting positions, especially under impressive cliff scenery. However, no matter how expert the skipper is at keeping them on station, boats tend to move around, so you will find the subject constantly changing. You need to work quickly, seeking out the important features. In particular, closely observe the tones and how the surf is interacting with rocks, cliffs and general shorelines. Once you have your main composition down on paper you can either apply colour or make colour notes, but it is the tones that will give shape to the features and thus form the basis of your composition.

Watercolour pencils are extremely versatile on a boat. You need just a few colours, with a number of strong darks such as black, indigo, grey, dark brown and sepia. Wetting the applied colours with a water brush does away with the need for a water container. Once you get home, you can finish off the work if you wish by laying on darker tones. You can, of course, go further, as in the case of the illustration below, where I have rubbed sandpaper across the tip of a white pencil over a re-wetted part of a dark area. This has created some lively white spots of foaming water.

Cliff structures in watercolour pencils

This small sketch was carried out with watercolour pencils, beginning with a light grey Prismalo pencil to establish the outlines, and then working in the colours with the Caran d'Ache Museum watercolour pencils which have superb blending qualities. It was completed in the studio to illustrate what can be achieved by these pencils.

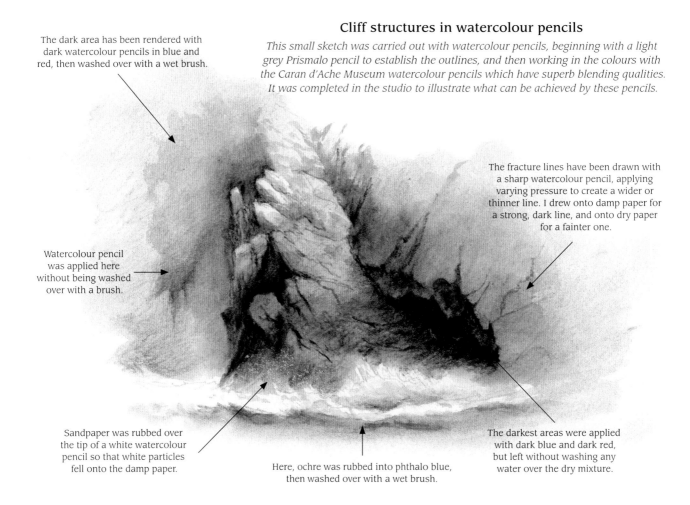

The dark area has been rendered with dark watercolour pencils in blue and red, then washed over with a wet brush.

The fracture lines have been drawn with a sharp watercolour pencil, applying varying pressure to create a wider or thinner line. I drew onto damp paper for a strong, dark line, and onto dry paper for a fainter one.

Watercolour pencil was applied here without being washed over with a brush.

Sandpaper was rubbed over the tip of a white watercolour pencil so that white particles fell onto the damp paper.

Here, ochre was rubbed into phthalo blue, then washed over with a wet brush.

The darkest areas were applied with dark blue and dark red, but left without washing any water over the dry mixture.

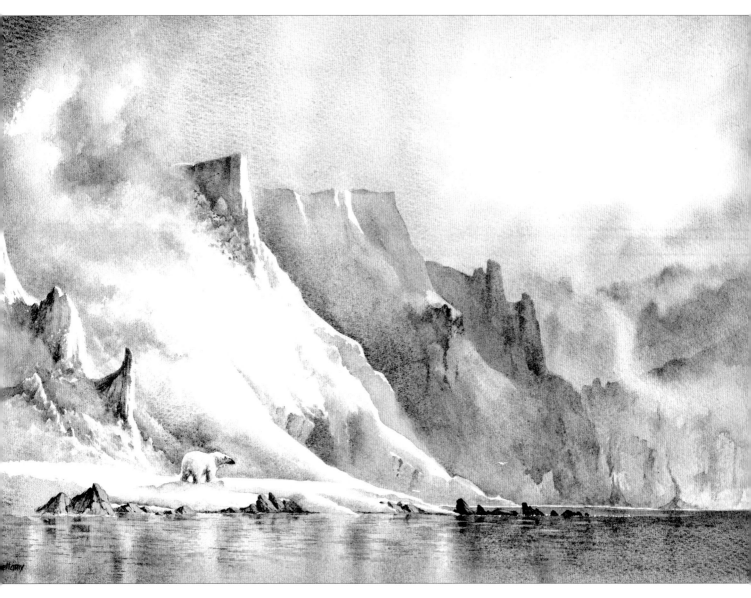

The Hunter
43 x 32cm (17 x 12½in)

I found this large male bear a little further along the Svalbard coast and decided to place him beneath these dramatic ice cliffs of Smithbreen Glacier where they plunge into the sea. Where fresh ice has calved off the glacier front, the colouring of the ice usually changes, so towards the right and directly above the dark rocks in the water I have brushed in some phthalocyanine blue to suggest this and freshen up that area.

The glacier top edge stands stark and sharp, so to reduce this effect I have introduced low clouds on the left by simply running the dark blue cliff-top into a wet passage, while to the right of this I have broken up the dark cliff with some white verticals which suggest buttresses caught in sunlight. The third place where I have broken the line is on the far right where I have pulled out a bending stream of cloud as it moves upwards in front of a lower part of the ice cliffs.

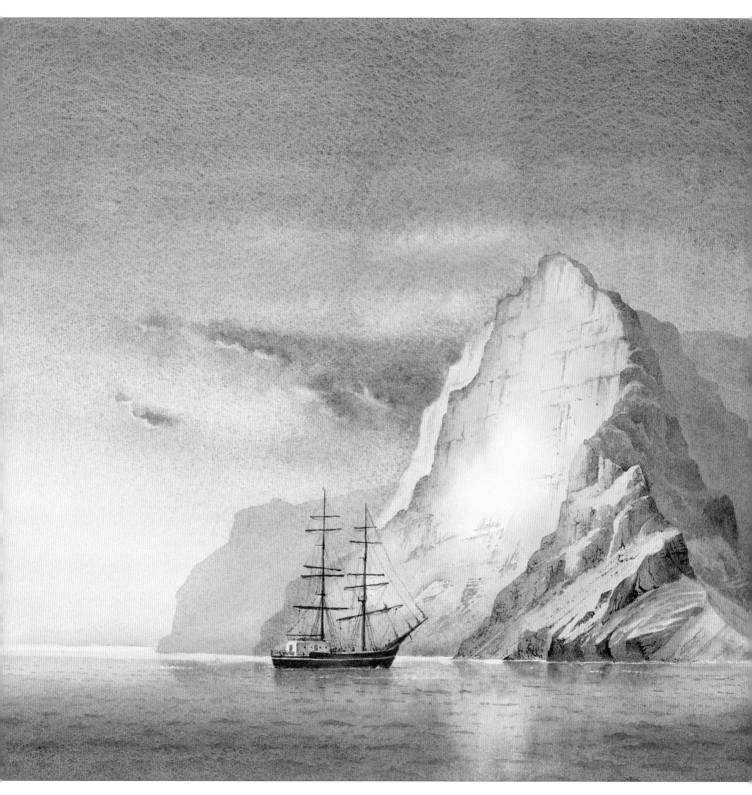

Los Gigantes
48 x 33cm (19 x 13in)

These gigantic cliffs on the west side of Tenerife dwarf the Roald Amundsen *anchored off-shore. As we passed I noticed a sailor working in a perilous position on the foremast yard. To render the slightly curved stays running up from the bowsprit I used a French curve.*

Subjects out at sea

Other vessels out at sea can make fine compositions, but you do need to work fairly quickly as both vessels − your subject and your own − will be moving and probably creating a constantly changing profile on your target subject.

Note how the craft relates to the sea, how it sits in the water, its wake and bow splashes. You may be lucky enough to have interesting light and tones on the water surrounding the vessel, but it's a good idea to look for these separately and not worry too much while working on the actual subject.

In the final painting you can bring in interesting sea conditions from a different spot. The same, of course, applies to the sky. It is vital to try out various compositions in studio sketches, for merely placing the vessel in a boring sea and sky environment is not going to enhance the painting.

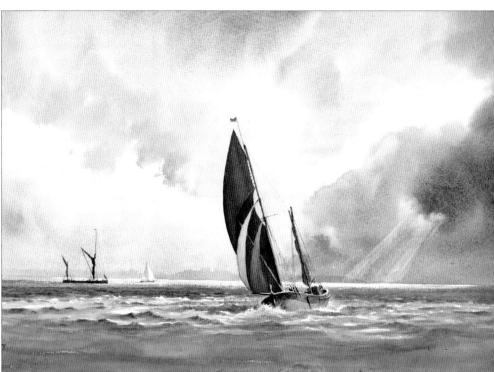

Cambria in a Following Wind
48 x 30.5cm (19 x 12in)

In this scene the old sailing barge is off Harwich where there were not only other vessels to provide background interest, but the wind and cloud shadows added a compelling mood to the sea. Ragged edges to the clouds emphasized the gusty nature of the day.

Painting sea and sky

Just as with landscape paintings, your composition will benefit enormously if you support your focal point – in this case the vessel out at sea – with another feature. Apart from a second craft or the odd oil rig there probably isn't much you can do other than feature an interesting passage of sea next to the vessel, plus maybe a suggestion of stronger colour or tonal value nearby. Generally there is little by way of wreckage floating around as there was in the days of Turner and Bonington, and probably the most you are likely to encounter are sad bits of plastic. However, the odd seabird might be worth including.

Atlantic Swell studio sketch

Because I intended this painting to include a potent atmosphere I laid the sketch out with strong pencil tones, noting the salient points such as the wave along which the boat appeared to be travelling.

1 I applied masking fluid to the wave highlights and a mixture of French ultramarine and bloodstone genuine over most of the sky and part of the sea, varying it in intensity. Phthalo blue was dropped into the sea in places.

2 I darkened the sea at the right horizon and then the sails with transparent red oxide. A little cadmium yellow light enlivened the sea below the boat. I then painted shadow colour on the left side of the splash and wave.

Atlantic Swell
38 x 24cm (15 x 9½in)

After removing the masking fluid I laid a glaze of French ultramarine and Bloodstone Genuine over the right-hand sky and sea to darken an lose the horizon. Finally I strengthened the red sail and darkened part of the foreground.

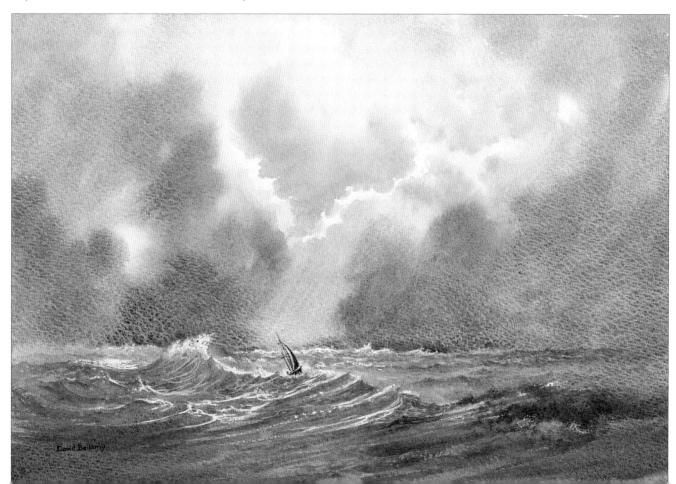

Painting wild seas

Working on the craggy coast of Pembrokeshire has given me countless opportunities for capturing wild seas and I love working in storms. Actually being out at sea in such conditions is of course a different matter, and best avoided at all costs. The alternative is to witness coastal storms from headlands and cliffs, but you need to take especial care to avoid being blown off your feet. If I can't find the shelter of a rock, I tend to lie or crouch down to keep the sketchbook and myself in low profile. The wind, however, is relentless and seeks out all your vulnerable spots, so you need loads of elastic bands and bulldog clips. Make sure you grip the sketchbook firmly.

With perseverance you can record the moving sea using the critical observation methods described earlier, and back this up with photographs. With regard to setting a vessel into such a wild sea, watch out for craft being tossed about offshore in boisterous conditions, and this will give you an idea of how it would appear in more threatening seas.

Lifeboat in Challenging Seas
48 x 28cm (19 x 11in)

The dramatic sky wash was laid on with a large brush loaded with sodalite genuine, while the wave structures were built up gradually with much negative painting to bring out the rough white tops. In places I have dropped in cadmium yellow light and yellow ochre while the initial blue-grey washes were still wet. A great deal of softening off has taken place using a 12mm (½in) flat brush, in particular where the lifeboat appears behind a wall of spray. The actual lifeboat is the Volunteer Spirit *from the RNLI reserve fleet, which I was lucky enough to witness roaring through the sea at full tilt.*

Dramatic granulation made in the sky was achieved using sodalite genuine applied with a large brush.

This passage was done with a 12mm (½in) flat brush loaded with little water, and the hairs parted with a knife. The paint was applied in the dry-brush manner, but tested first on similar scrap paper.

Stab and scratches with a scalpel helped to create white blobs and streaks of aerated water.

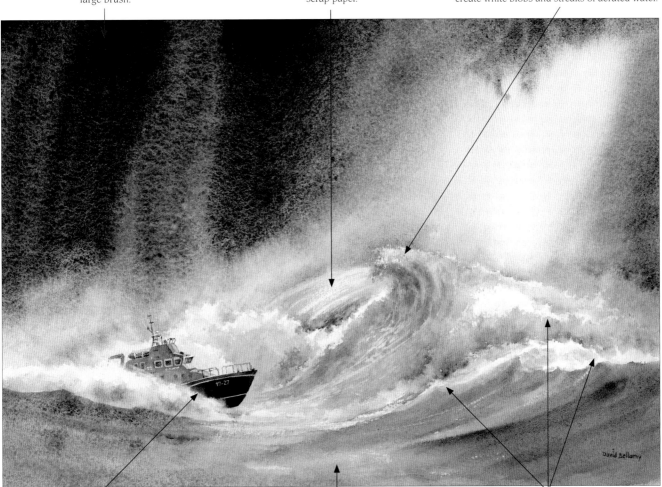

The lifeboat has been positioned in the composition so that it is off-centre and running into the picture. The top edge of the spray that partially hides the boat was softened off with a 12mm (½in) flat brush once the paper was dry.

Little foreground detail has been included to ensure the emphasis falls on the boat and wave.

The ragged edges to the crests of waves were achieved by scrubbing the side of a no. 8 round brush across the paper and softening it in places.

Painting on holiday

Planning a trip

Whether you are taking a local trip or a holiday abroad it pays to give it careful planning: forgetting a vital piece of equipment can be disastrous from a painting point of view, as art shops close down with regularity and finding good ones abroad can be something of a lottery. When flying there is always the chance that your baggage may end up in Kuala Lumpur instead of the Amalfi Coast, so I always ensure I have a basic painting kit in my hand luggage as well as that in my case. A range of watercolour pencils can also be a fine insurance in case you lose a box of watercolour paints, while brushes and pencils can be stashed in a variety of places.

I often take a block of Not watercolour paper as this is convenient and does not need stretching, but more importantly I like to take a folder containing various papers, such as Rough, hot pressed, Not, tinted and loose cartridge. This folder measures 35.5 x 25.5cm (14 x 10in) and the papers are held in place by fine cord with each sheet bent in half. This system saves me carrying around a whole pad of each type of paper.

Guidebooks, the internet and tourist offices can usually provide galleries of photos of your target area, and this helps enormously when working out places to visit to paint and routes to walk along the coast.

Don't let meeting locals while sketching or painting put you off. In most countries the local people are usually kind and often eager to help you with information about the subject, or other places where you might find similar ones, and this is something you should encourage rather than hide away from. On many trips these moments of interaction with locals have been definite highlights.

Beware of laying out all eighty-four watercolour pencils in your pristine box, as in some countries this is really tempting for the children. While it is nice to be able to give them a few pens or pencils you may take especially for that purpose, it becomes a completely different game when half the village children descend on you like locusts!

Norwegian Coast

This was a rough sketch carried out on a ship sailing down the Norwegian coast off the Lofoten Islands, around 11.30pm. I saw the peaks lit up by the dying sun, and as I was in the bar with little gear I was obliged to sketch in watercolour pencils with beer.

Franciscan Monastery, Cavtat
In this sketch I used only burnt umber, despite there being plenty of colour in the scene. This approach lends a strong sense of unity to the work.

Los Cristianos Harbour
This watercolour sketch was carried out with a backdrop of stormy skies which was very appealing when set behind the mass of white buildings overlooking the harbour. I became so excited by all the varied detail that I lost myself in the composition rather than treating it seriously. There is no one focal point, but this doesn't matter – for a finished painting I can pick one out easily, whereas with the sketch it was pure enjoyment of the moment.

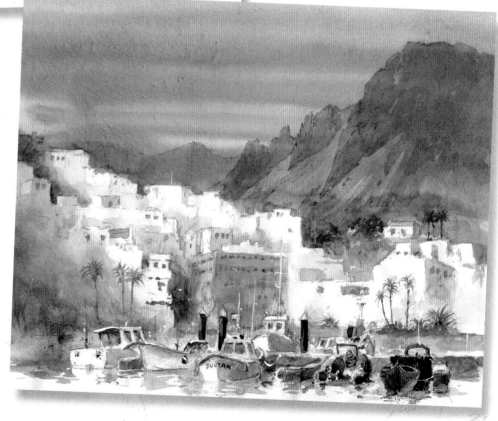

Group holidays

Painting with a group on holiday can free you from the many distractions of organizing and finding locations to paint. You may also feel safer, and so long as you have an affinity with the tutor's work and enjoy the sort of location you will be visiting, then this option may well suit you. If you feel you'd like time to do your own thing on occasion, then discuss this in advance. We all work at a different pace and normally there is flexibility in the arrangements. While watching a demonstration on site it's not a bad idea to do your own sketch, working on the quieter moments, but absorbing the tutor's commentary and making notes. If you don't wish to attend a demonstration just politely tell the tutor you are going to do your own thing this time. The important thing in all this is for you to get the most out of the holiday and a good tutor will always appreciate this and understand that not everyone wants to concentrate on a particular type of subject.

Close-up of the harbour restaurant.

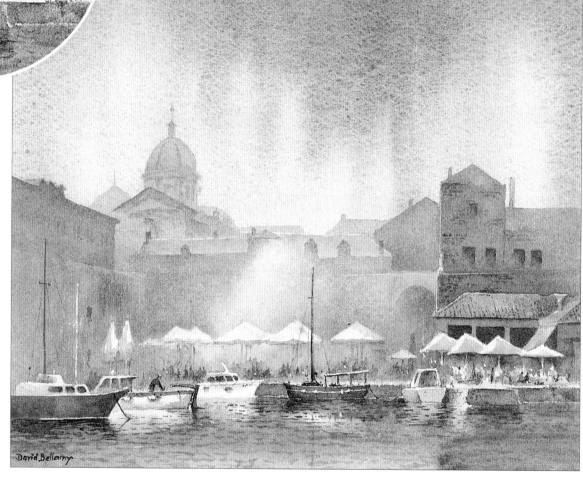

Dubrovnik Harbour
48 x 28cm (9½ x 8in)

I did the original sketch as a watercolour monochrome demonstration for a painting group, and became mobbed in the process, as I sat in an exposed position. Every detail of the harbour and its boats was clearly visible, but I introduced a little smoke and haze into the scene to lose certain features in places, especially as the white canopies are repetitious. The reflections were achieved by leaving areas of white below the white boats and dropping in the colours of the other boats in a similar position, all done into a medium grey wash. I quickly dropped in the other dark reflections of the harbour wall, then allowed it all to dry. The next stage was to stab in the little grey ripples with a fine no. 4 round sable, then laying a light grey glaze over the whole area of water, thus reducing the brilliance of the white reflections a little.

Painting and sketching abroad

In exotic places you may well find yourself being pestered not so much about your painting, but by people trying to sell you something. If this is particularly troublesome, it sometimes helps to hire a recommended guide who can protect you from such intrusions, as well as help you find subjects. They tend to cotton on quickly once they've watched you work for a while.

Excessive heat can make laying washes difficult as they dry so quickly. A small drop of glycerine can help prolong the drying period. Beware of using hot-pressed paper as a smooth paper will dry more quickly than a Rough or Not surface. One technique I adopt in very hot conditions is to liberally soak the paper directly before laying a large wash. Masking fluid can also help, as once you have covered the places where you don't want the paint to go, you can then work with speed without having to slowly work round each shape abutting the wash.

Consider keeping an illustrated journal as these can provide a fascinating record of your trips.

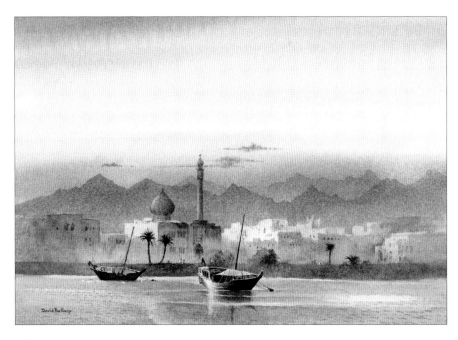

Dhows at Mutrah
30.5 x 20.5cm (12 x 8in)

Evening light catches the curved side of the hull of the right-hand dhow, and its reflection was pulled out with a 12mm (½in) flat brush. Note that the background has been kept soft and devoid of much detail to suggest distance, though the mosque and palm trees are more prominent. Simple skies like this, where only a few small clouds have been introduced wet into wet, can be extremely effective.

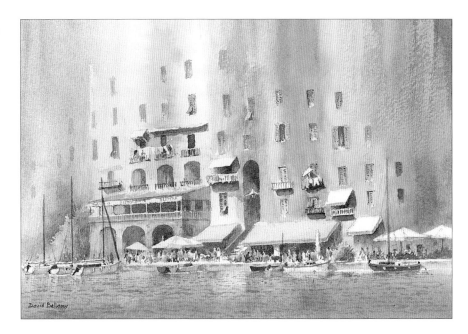

Portovenere
25.5 x 18cm (10 x 7in)

The seafront at this delightful resort is colourful, but it is easy to get into the trap of painting every building and every door, window and canopy the precise colour you see. Allow colours to blend into each other to create a more painterly manner. Change colours and shadows to suit yourself. Make them more intense or bright to accentuate parts of the scene. Move features and people around to improve your composition.

MYKONOS HARBOUR

After considering my initial sketch of the church (see below) I felt this scene needed more than just what was shown: I wanted to make more of the side where the shadows cast from the trees emphasized the strong sunlight. I also wanted to make the background more appealing, and to add a boat to both support the focal point and to break up the shoreline. I drew a studio sketch partly based on the original one, adding detail from photographs and a sketch of the boat.

Materials used

Saunders Waterford 425gsm (200lb) Not watercolour paper, high white

Brushes: Large squirrel mop; no. 6 round; 12mm (½in) flat synthetic; no. 10 round; no. 4 round; no. 3 round; no. 1 round; 6mm (¼in) synthetic flat

Colours: Lavender; cerulean blue; raw umber; French ultramarine; cadmium red medium hue; green apatite genuine; quinacridone gold; lemon yellow; moonglow; quinacridone red; quinacridone sienna; yellow ochre; burnt sienna; burnt umber

3B pencil

Kitchen paper

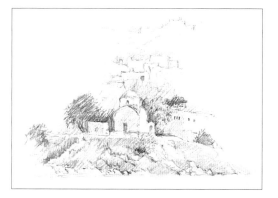

Initial sketch (made in situ).

Studio sketch.

1 Using a 3B pencil, draw out the scene. Wet the whole sky with clean water, using the large squirrel mop. Work over the top of the mountains, but carefully around the buildings. Change to the no. 6 brush if it helps you work round the buildings. Using the mop brush, lay in a wash of a sky mix of lavender and cerulean blue.

2 Change to the 12mm (½in) flat synthetic brush. Wet it, then squeeze out the water to leave just a little dampness. Allow the sky to dry to the point that the sheen is starting to disappear, then use the blade of the brush to lift out a couple of small, subtle clouds at the level of the mountain tops. Allow to dry completely before continuing.

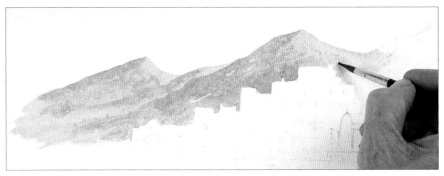

3 Place the background mountains with a dilute wash of raw umber. Use the no. 10 round brush to apply the paint, working carefully around the buildings.

4 Add a touch of raw umber to French ultramarine, and use the no. 6 round brush to glaze the mountains in places to establish the texture and shadow areas. The light is coming from the right-hand side, so place most of the shadows on the left-hand side of the mountains.

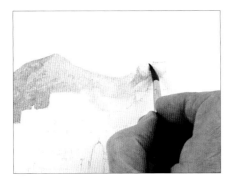

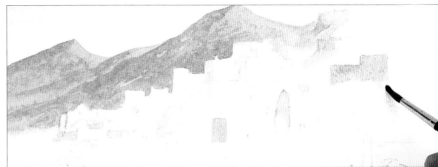

5 Add cadmium red medium hue to your sky mix (lavender and cerulean blue), and use the no. 6 round brush to begin to paint the shaded sides of the buildings on the ridge. Extend the paint down the mountainside as cast shadows.

6 Apply the same colour to the shaded sides of the remaining buildings. To suggest reflected light coming from nearby buildings or the ground, clean the brush and use the damp point to draw out a little of the wet paint from the bottom of the shaded shape.

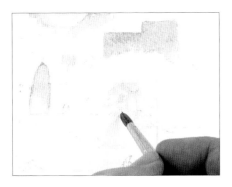

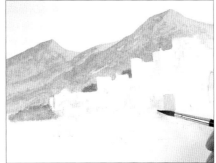

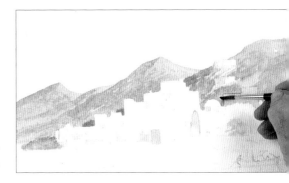

7 The trees will also cast shadow. Use the side of the no. 4 brush to make a slightly dappled shape to the lower left of the tree, developing the texture with the tip.

8 Still using the no. 4 round brush, mix raw umber with green apatite genuine and use this green mix to paint the trees in and amongst the buildings. Add some hints of quinacridone gold below the tree in the centre with the no. 6 round brush.

9 Working down the ridge of the mountain on the right, add touches of raw umber to fill in the area, providing some definition to the edge of the buildings. Add some touches of green apatite genuine wet into wet.

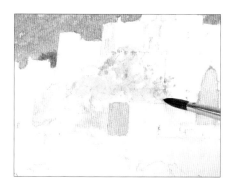

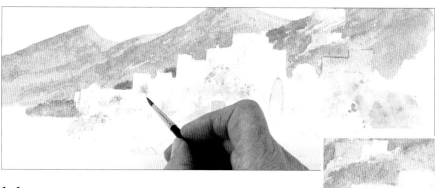

10 Mix lemon yellow with green apatite genuine for a fresh green, and use stippling marks to suggest sunlit foliage on the central tree.

11 Do the same for the tree on the right-hand side and the small trees in the foreground, then paint the palm trees with green apatite genuine, applying the paint carefully with the point of the no. 3 round brush. As you work, you may spot some parts that unbalance the tones. You can glaze these to darken them, or use the 12mm (½in) synthetic flat brush and kitchen paper to lift out a little paint in order to lighten them (see inset).

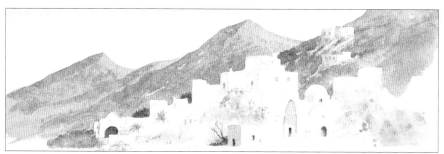

12 Add some contrasting dark tones near the light central area, using a mix of French ultramarine and burnt umber with the no. 3 round brush. While it is still wet, use the no. 1 rigger to draw the mix up to create the trunks of the trees.

13 Change back to the no. 3 round brush. Add selective glazes of the greyed sky mix (lavender and cerulean blue with a touch of cadmium red medium hue) to the side of the distant building, in order to make it stand out a little more against the other building. Use the same brush and mix to add in the windows and doors across the buildings. Reinforce some of the closer apertures with moonglow.

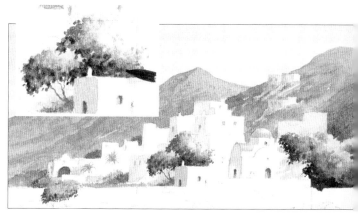

14 Change to the no. 6 round brush. Paint the dome and roof on the church using quinacridone red with a hint of yellow ochre. Reinforce the colour in areas, and add moonglow while wet for shadows. Using a mix of raw umber and green apatite genuine, start to add deeper shadows to the trees. Use a stippling motion towards the edges of the foliage.

15 Add French ultramarine to the mix, and add the very dark shadows in the same way (see inset). Still using the no. 6 round, build up the foliage across the painting using the same brush and mixes.

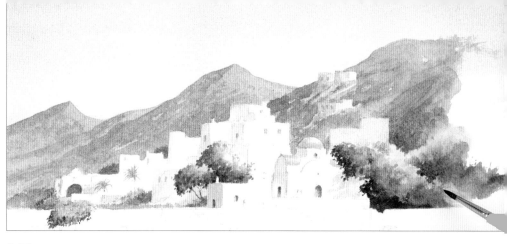

16 Change to the no. 4 round and use a dark mix of raw umber and French ultramarine to paint in the trunks of the palm trees and the dark, shaded fronds, then use a pink mix of quinacridone red and yellow ochre to paint the roof of the nearby building.

17 Take a step back and look for any small areas or features that need to be adjusted – either knocking back intruding areas with lifting out, or strengthening too-weak areas with a few additional details or glazes. Here, I have added a few windows to the building behind the church; glazed French ultramarine over the shaded building near the palm trees; and added a small lamp post with the no. 3 round brush and a dark mix of French ultramarine and burnt umber.

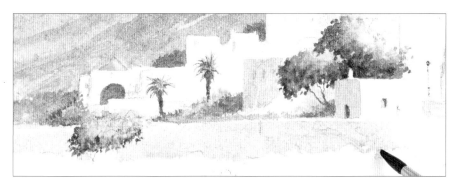

18 Begin to develop the sea wall using the sky mix of lavender and French ultramarine, applying the paint using the no. 6 round. Add some yellow ochre wet into wet.

19 Using the no. 1 round brush, pick out the figures in front of the church using some of the brighter colours on your palette for their tops, and moonglow for darker areas.

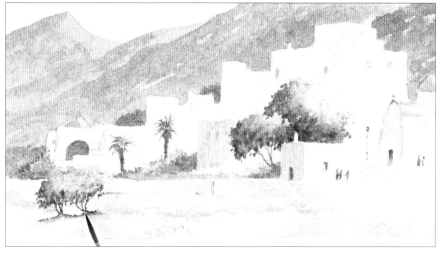

20 Add the parasol with a mix of lemon yellow and quinacridone gold, then lay in the beach with yellow ochre and the no. 10 brush, then develop the shadows around the trees on the right-hand side with a mix of French ultramarine and moonglow. Lift a little of the paint out for highlights on the wall using the 6mm (¼in) synthetic flat brush.

21 Using the same mix of French ultramarine and moonglow, add the cross on the church and trunks to the trees on the lower left-hand side using the no. 1 rigger.

22 Change to a no. 6 round brush and paint the rocky foreshore using French ultramarine, raw umber and a few touches of yellow ochre.

23 Using the no. 1 round brush, begin to detail the boat. Use a dark mix of French ultramarine and burnt sienna for the parasol stand and figure beneath, then switch to quinacridone sienna for other details.

24 Add shadow to the hull of the boat using the no. 4 round brush and French ultramarine, softening the colour in towards the centre.

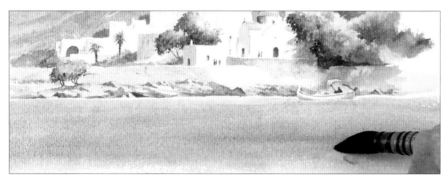

25 Before starting the sea, I have added some further detail to the rocky foreshore with the no. 1 round brush and the dark mix of French ultramarine and burnt sienna. Using the squirrel hair mop brush, lay in broad horizontal strokes of French ultramarine, then add phthalo blue wet into wet.

26 While the paint is wet, use a damp no. 10 brush to lift out some reflections of the central buildings by drawing the brush down from the top of the water.

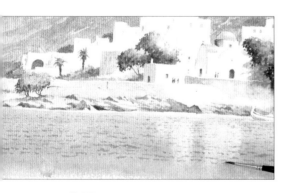

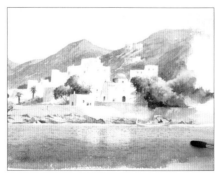

27 Allow the sea area to dry. Using a no. 1 round brush and moonglow, add ripples across the sea, starting from the top and centre.

28 Add cadmium red medium hue to French ultramarine and use the resulting rich mix to glaze the lower part of the sea, using broad strokes of the no. 10 round brush.

29 Clean and rinse the no. 10 round brush and wet the sky area, leaving the clouds dry. Add slightly diluted cerulean blue into the wet area with horizontal strokes. Use a wet brush to draw the wet paint down into the valleys between the hilltops.

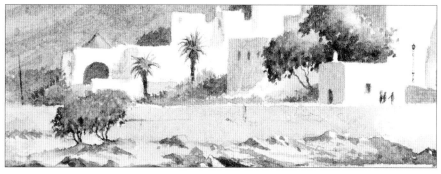

30 Add some cargo to the boat using permanent orange and the no. 1 round brush, then change to the no. 1 rigger and add a mast and rigging with white gouache.

31 To finish, make any final tweaks you feel necessary. I have strengthened the shadows on the central buildings, and warmed the trees on the lower left-hand side, to help differentiate them from each other.

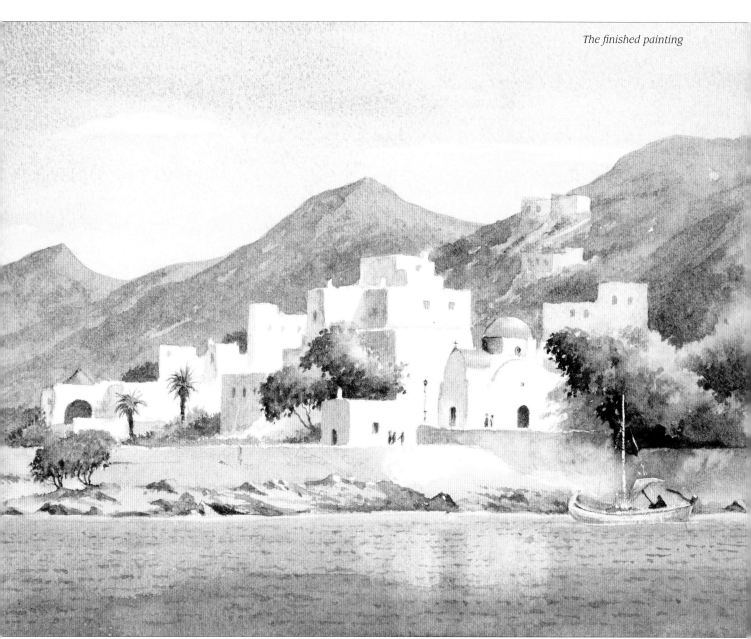

The finished painting

Index